fagart

logan benedict

fagart
Copyright © 2017 by Logan Benedict
All rights reserved
ISBN: 1541382811
ISBN-13: 978-1541382817

this is for you to mull over

always put yourself first
and let your heart heal

fagart

july 7 2016

making sense of the nonsense

rushing production until the mind collapses in exhaustion

i will vomit blood for years if it means the world will see what i have been saying

i will vomit blood for years if it means the world will understand what i've been drawing

i will vomit blood for years if it means the world will taste my bones and observe my creation for a solid minute in utter silence

i will chew glass shards until my stomach ruptures just to spend some quality time with you

please whisper gunshots in my ears and lick my shoulder blades

this may be a run-on sentence but i've been running after you for three lifetimes

"still here"

may 25 2014

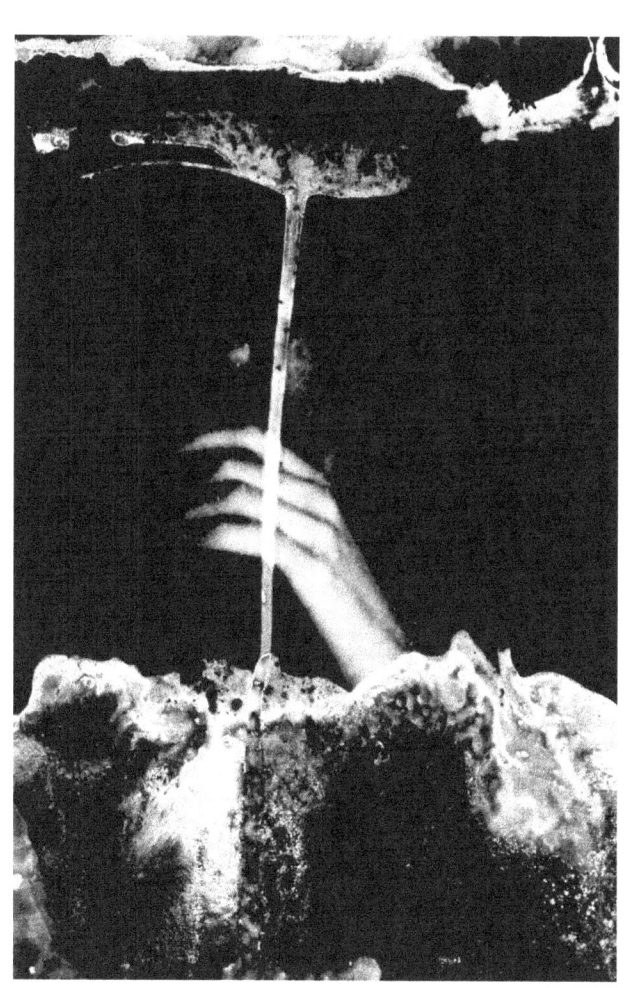

"wounds"

june 27 2014

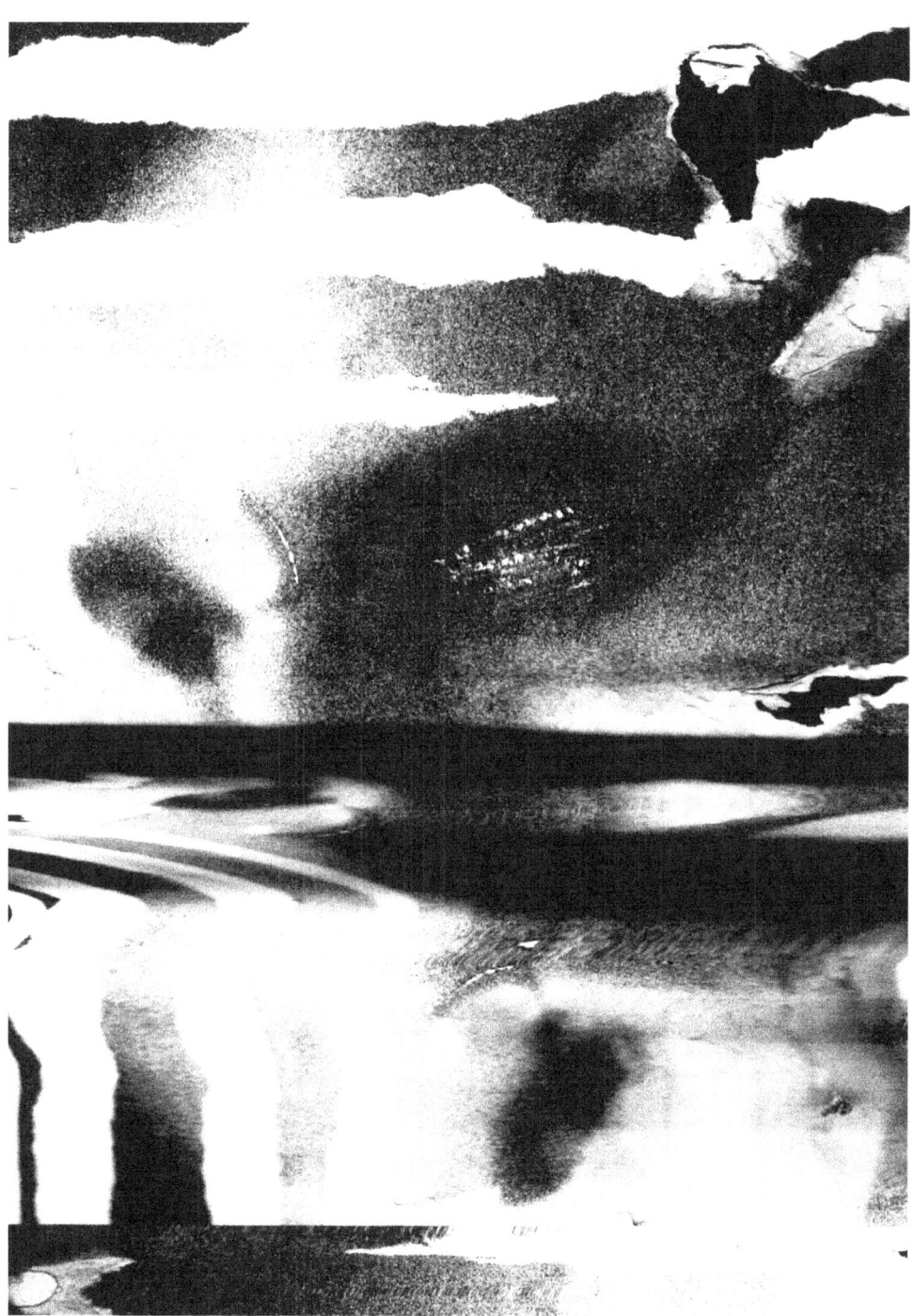

"fury rage sinking serenity"
september 7 2015

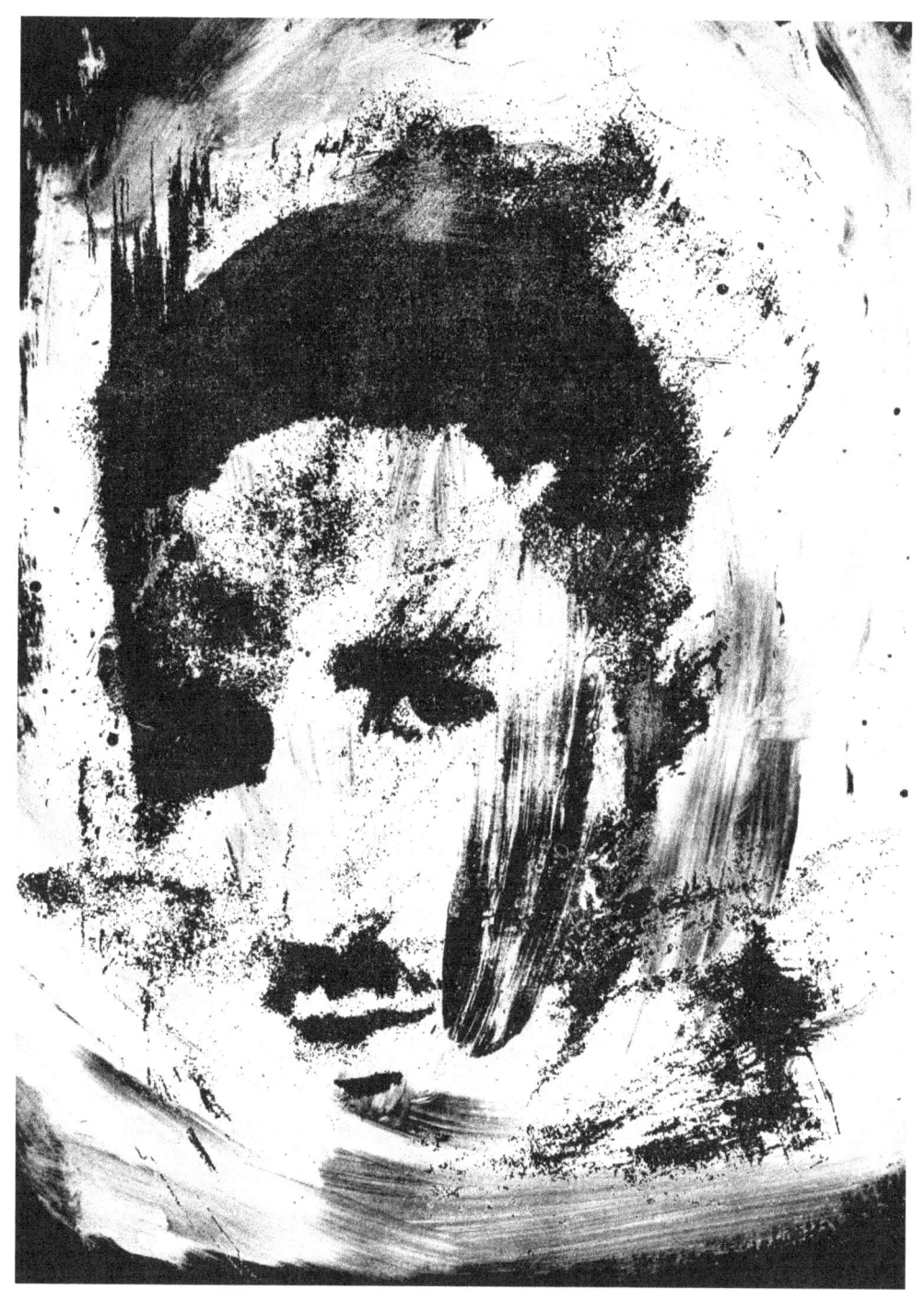

july 23 2016

we tiptoe on graves while cymbals crash in the distance

we feed the fire with the ashes of yesteryear

we remember the fallen by falling even harder than them

we pierce our flesh with safety pins and ridicule

we dress like the nightclub nightcreatures of yesteryear

we shoot ourselves in the feet and forget about it

we trace the earthquakes with our fingers and put on our fishnets

we jump from boulder to river and back again like nobody's business

we close our eyes and let the world consume us

we use the asphalt as aspirin

"morally bankrupt"

november 15 2015

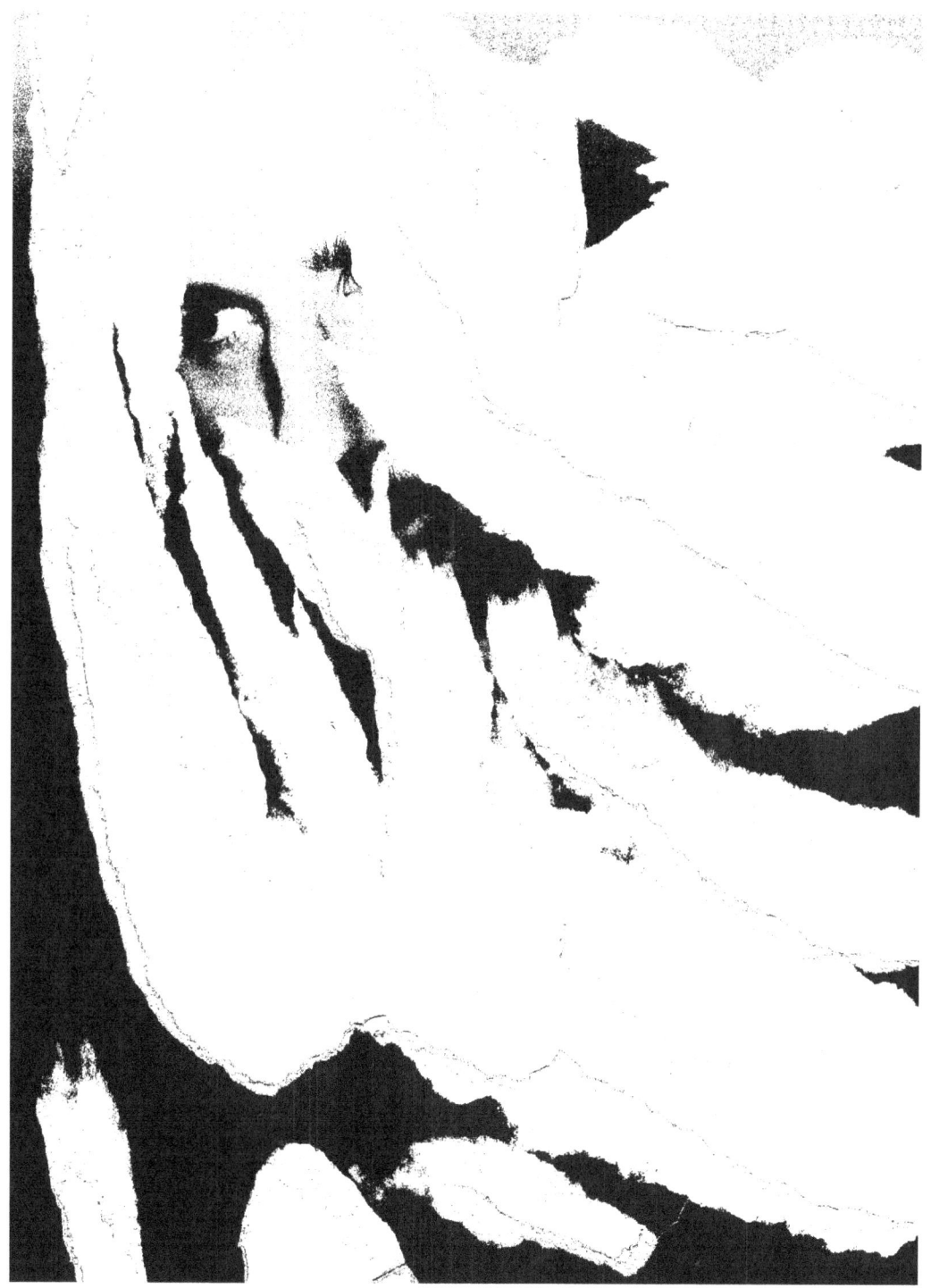

"no one ever cared that you were in that room"
november 15 2015

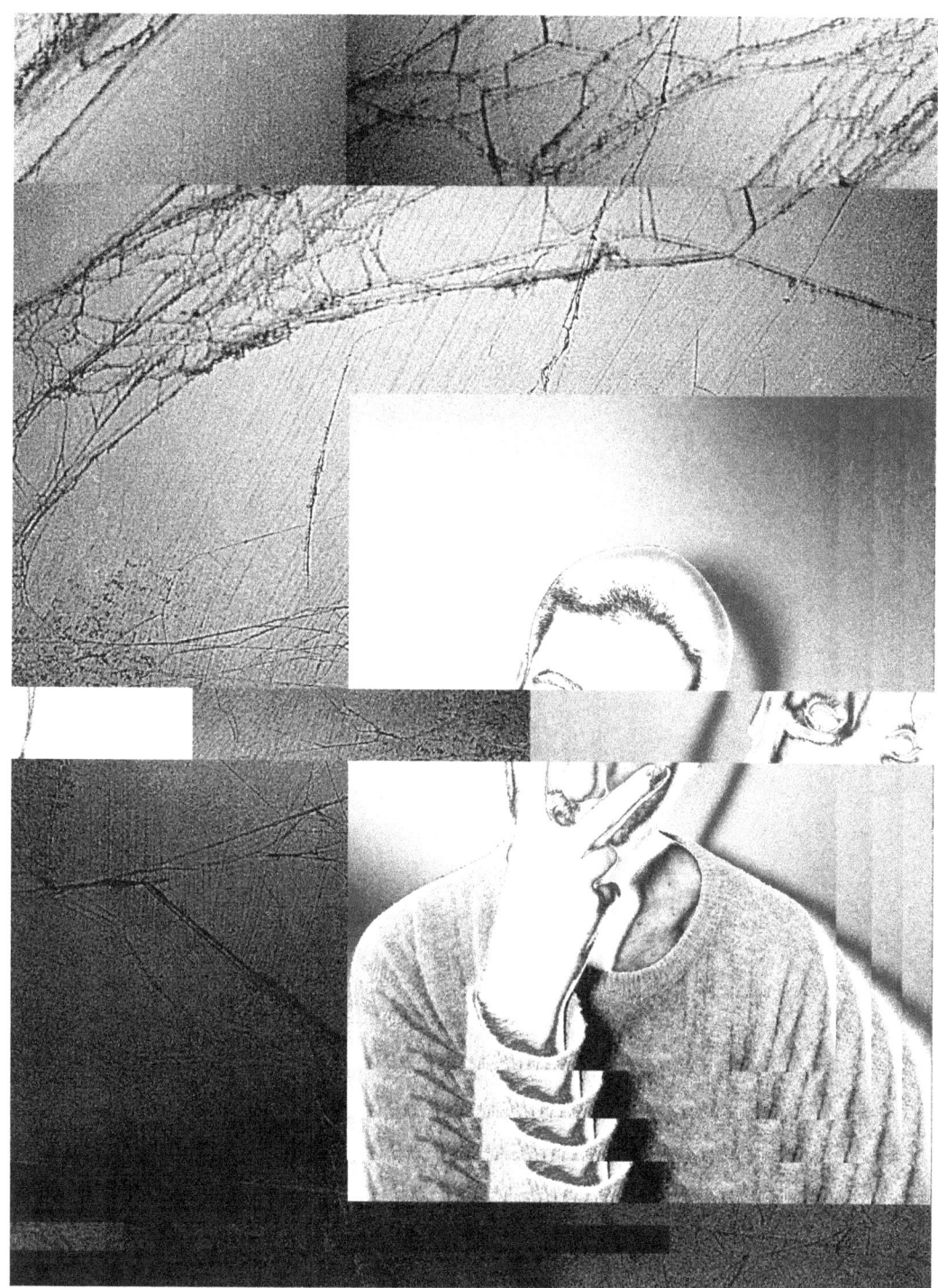

december 21 2016

the boy i loved moved to Australia

he said i was something and my skin is still tender

the wound wouldn't heal easy

i was waiting by the phone for weeks

"ryannight (color me black)"

january 2 2016

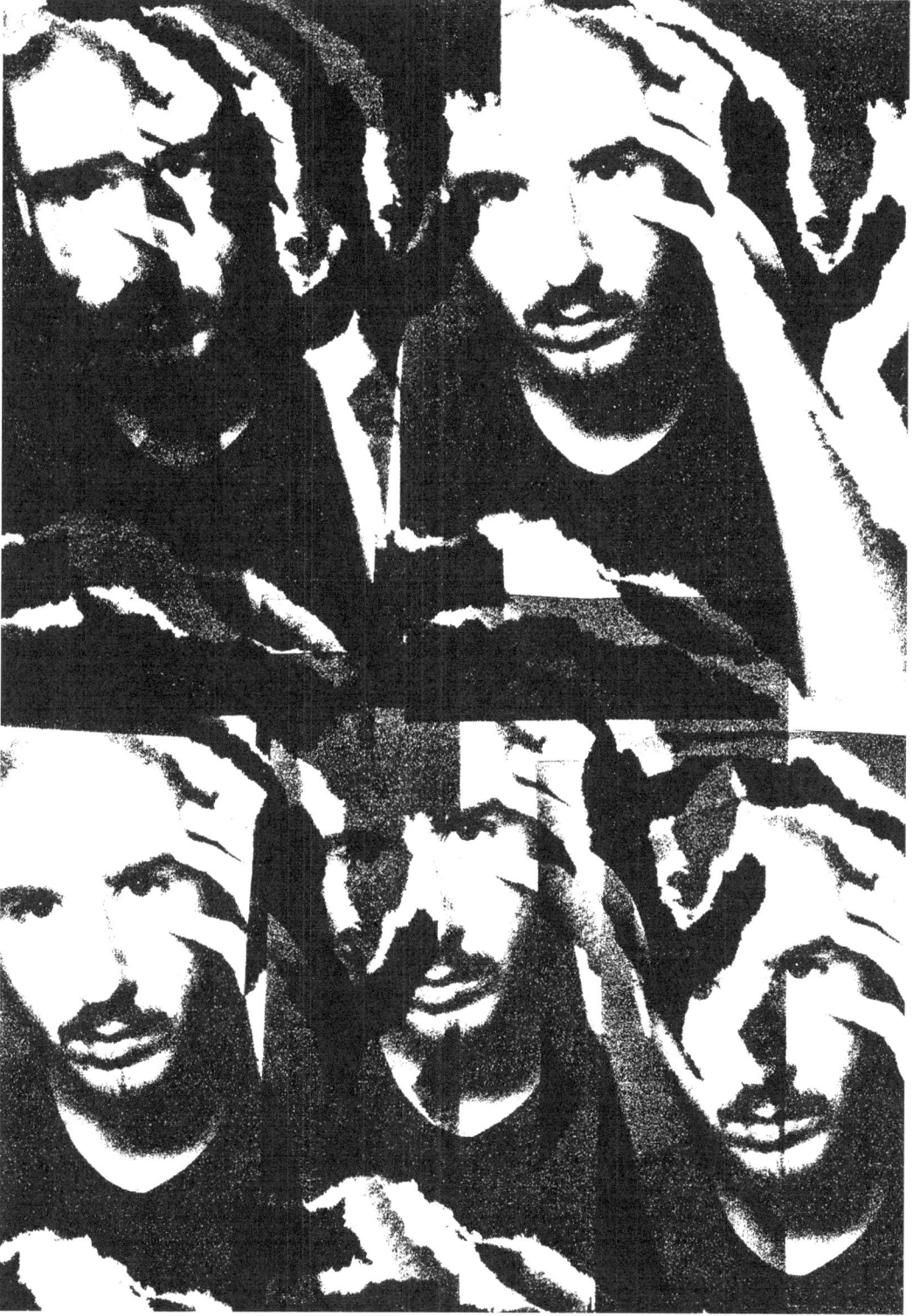

"he arose"

january 9 2016

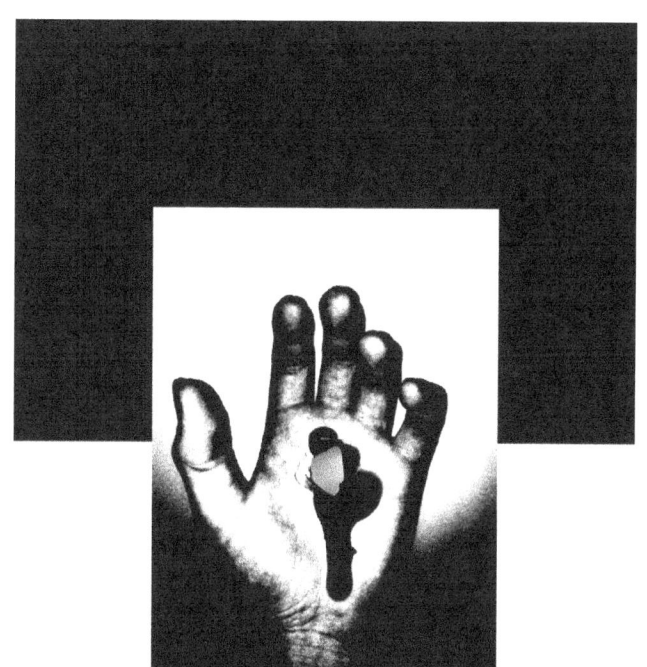

"forged future"

january 17 2016

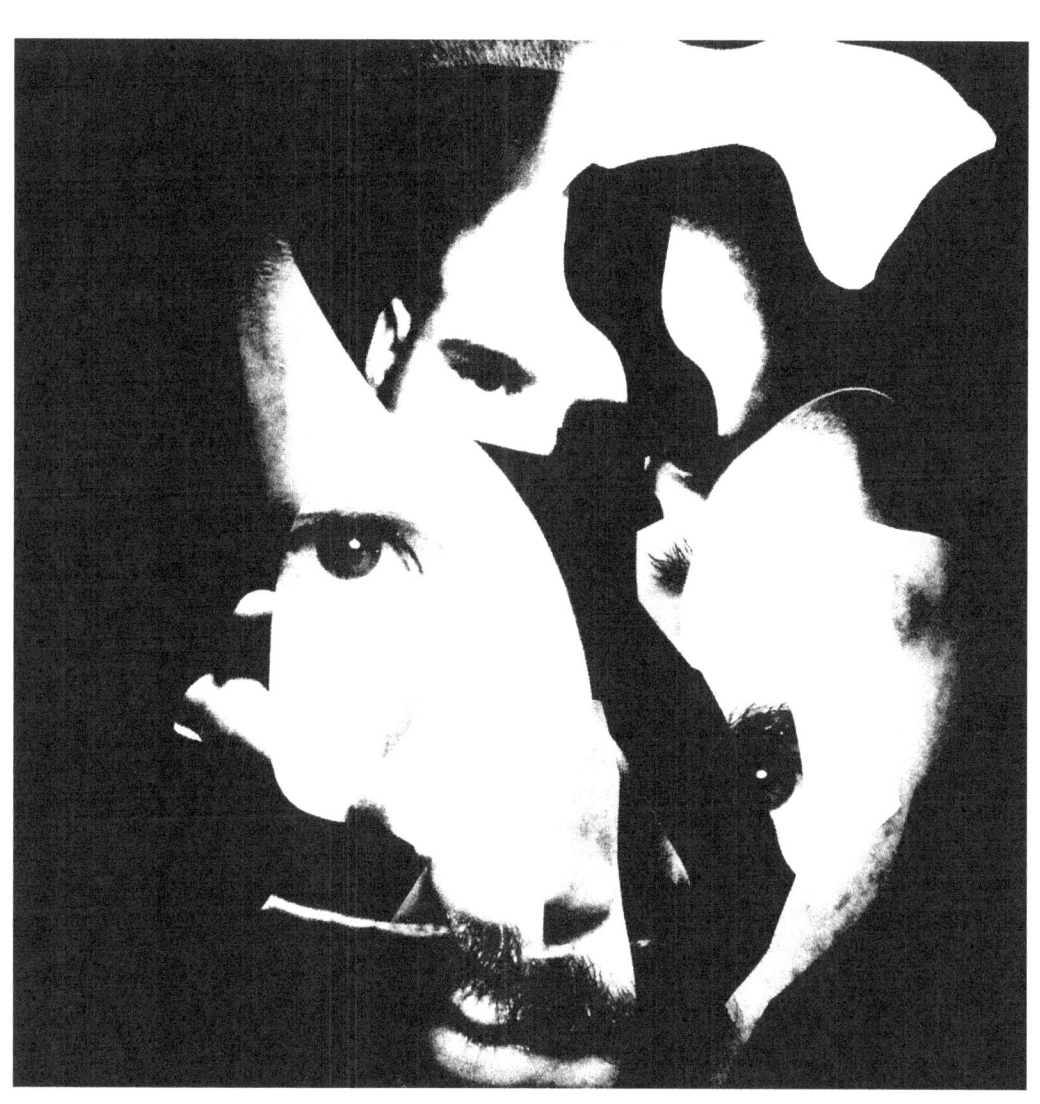

"dead heroes"
january 18 2016

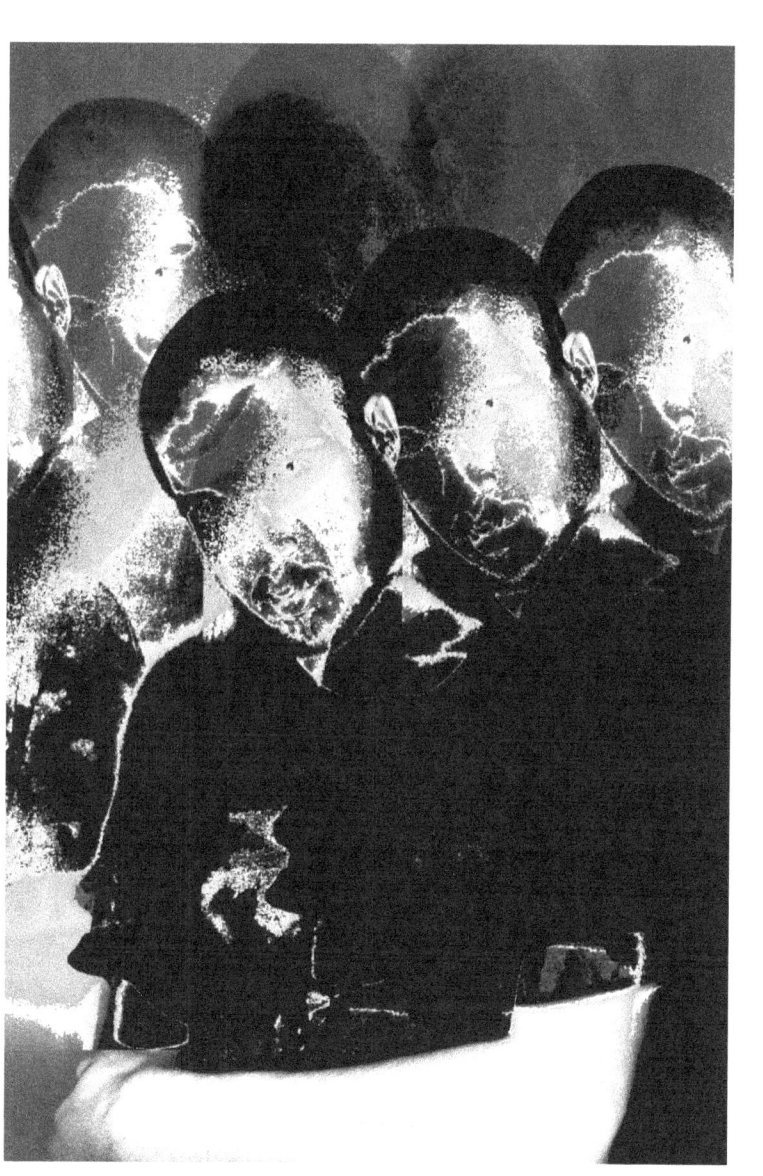

august 19 2016

concrete babbling concealing feelings healing even in a blackboard wasteland

stumble stumbling into starry night fight fighting the need to sleep and persisting to keep my wide eyes open glazed awake flaxen seed

heed and share your need to breathe with me your soul mate your angel dust companion your common ground gravedigger

we fall into each other like blind newborn cats unseeing unearthing understanding the freedom of new wave thought and nickel scarves

"cries of nature (running innocence)"

january 28 2016

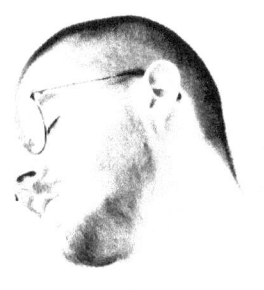

"suck it harder"

february 21 2016

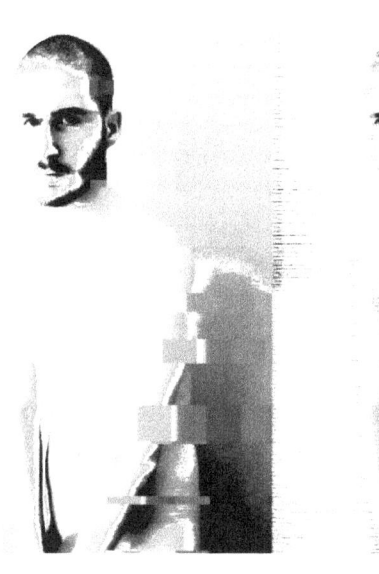
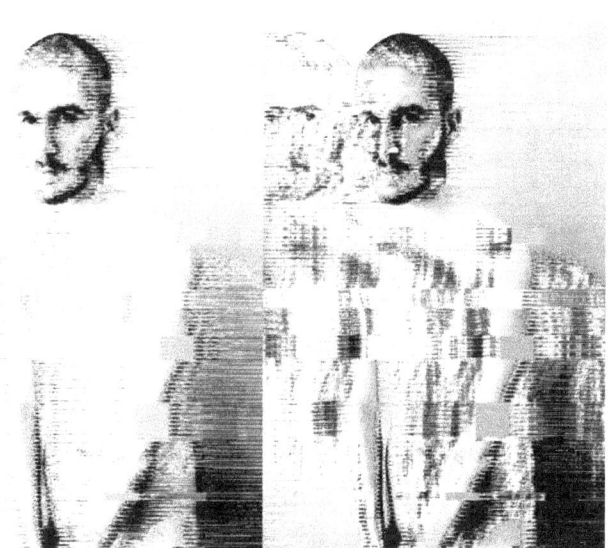

"surrender to the situation"
february 21 2016

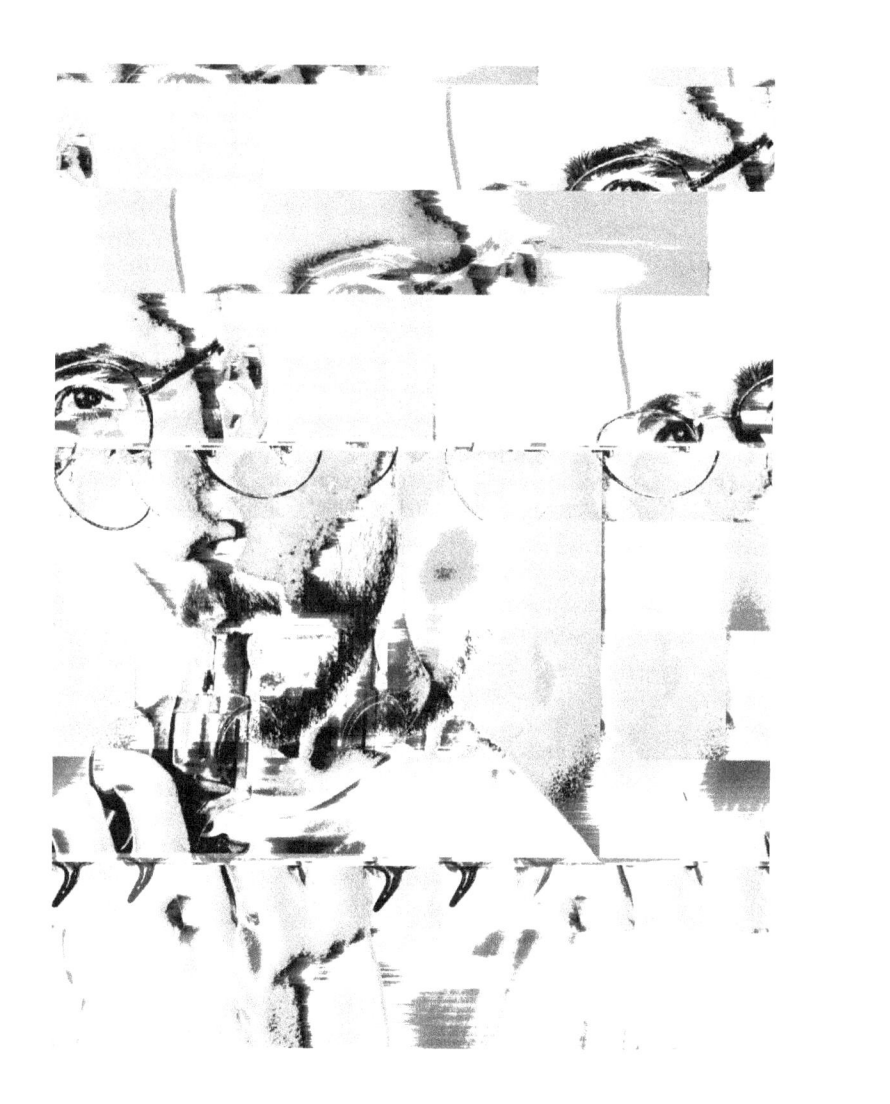

november 20 2016

i divorced your name

carved a cross into my palm

fed the trees with yearning

now dusty ashes gather here

"hated skin"

february 25 2016

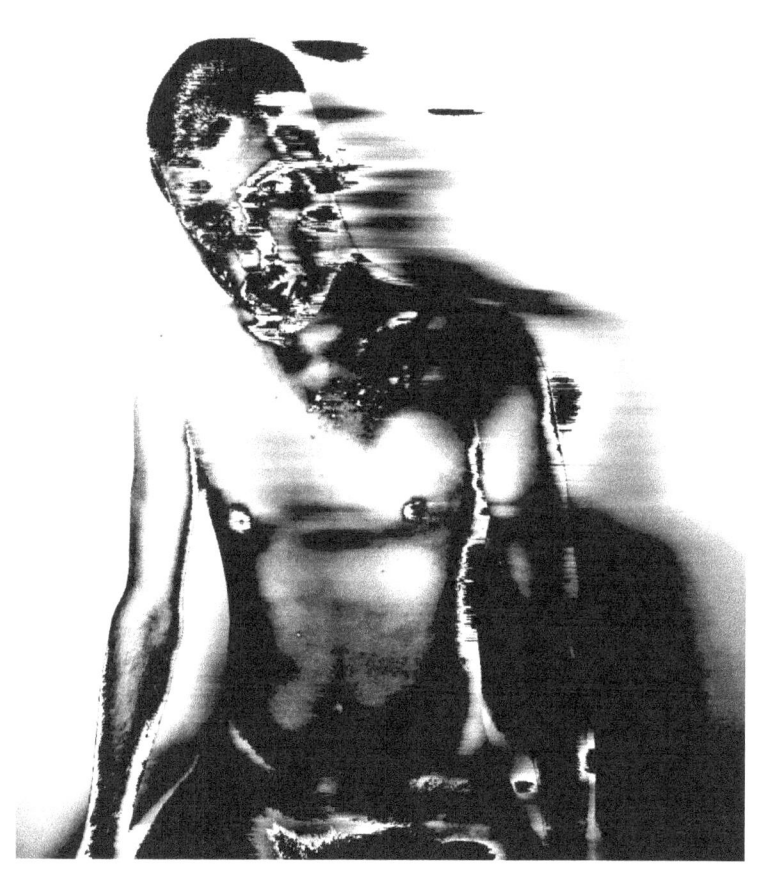

"falling asleep at the wheel"

february 27 2016

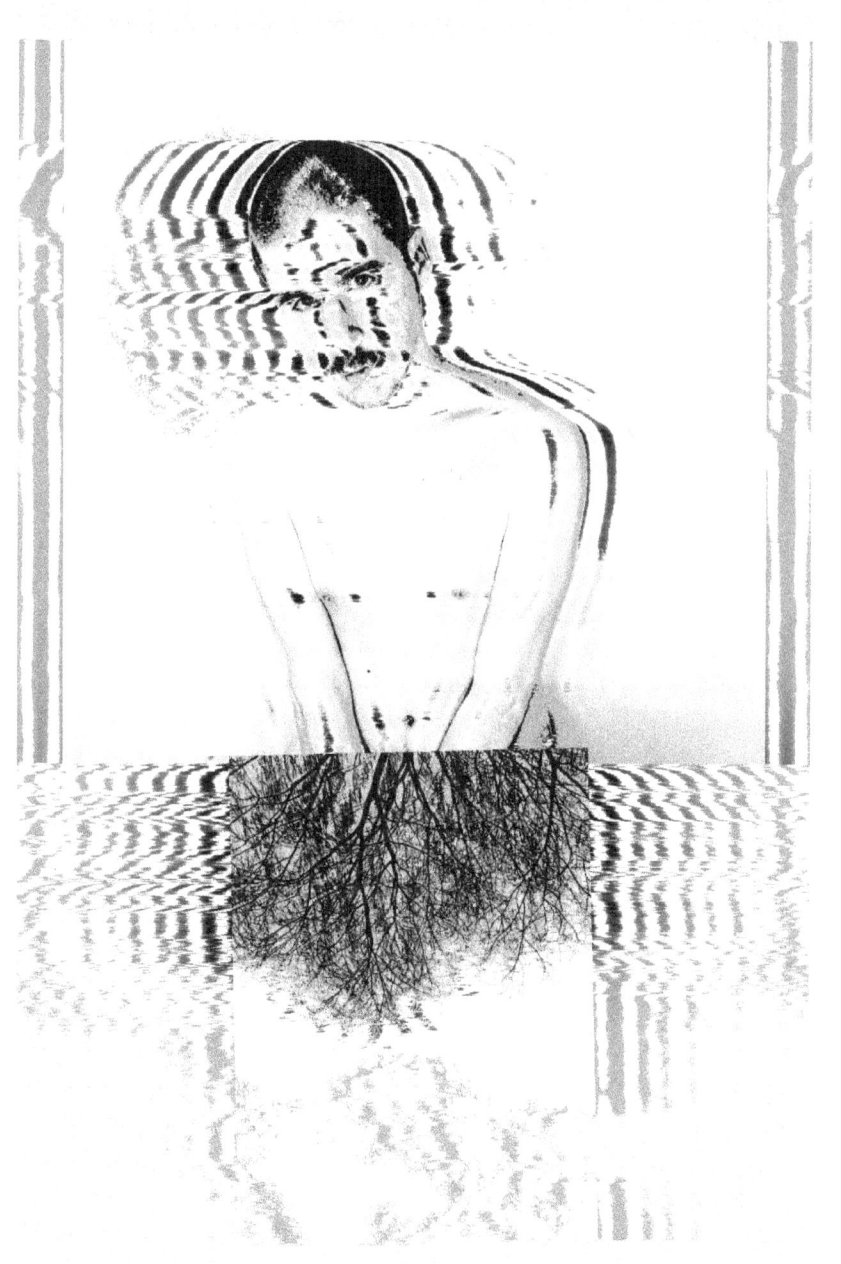

"all that is solid melts into air"

march 13 2016

"i isolated myself"
april 5 2016

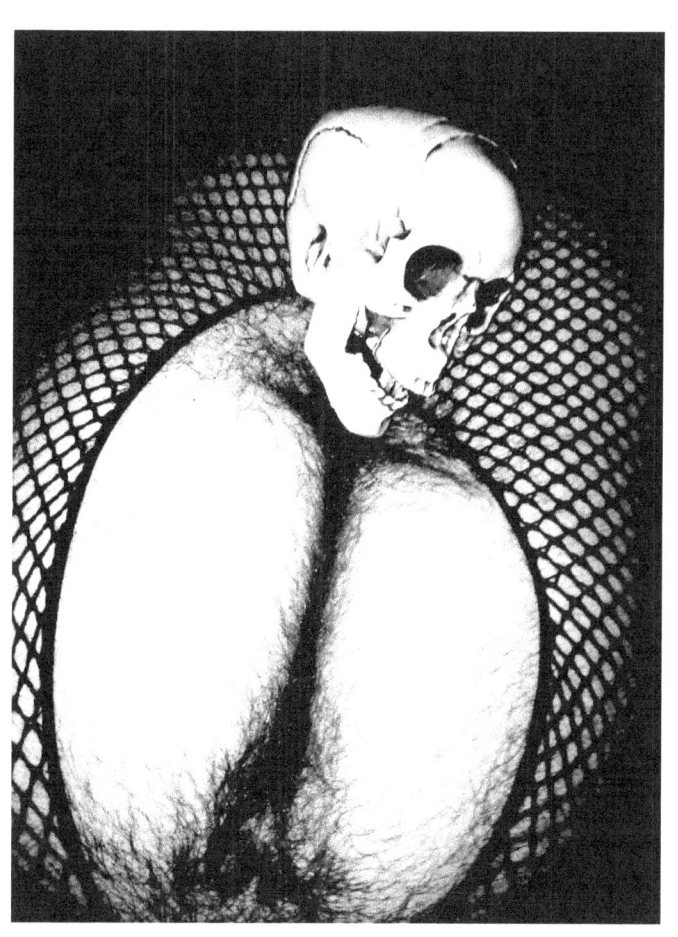

december 22 2016

i say goodbye to nobody

i break the knots

i sing the milky blues

"akin altars"

april 7 2016

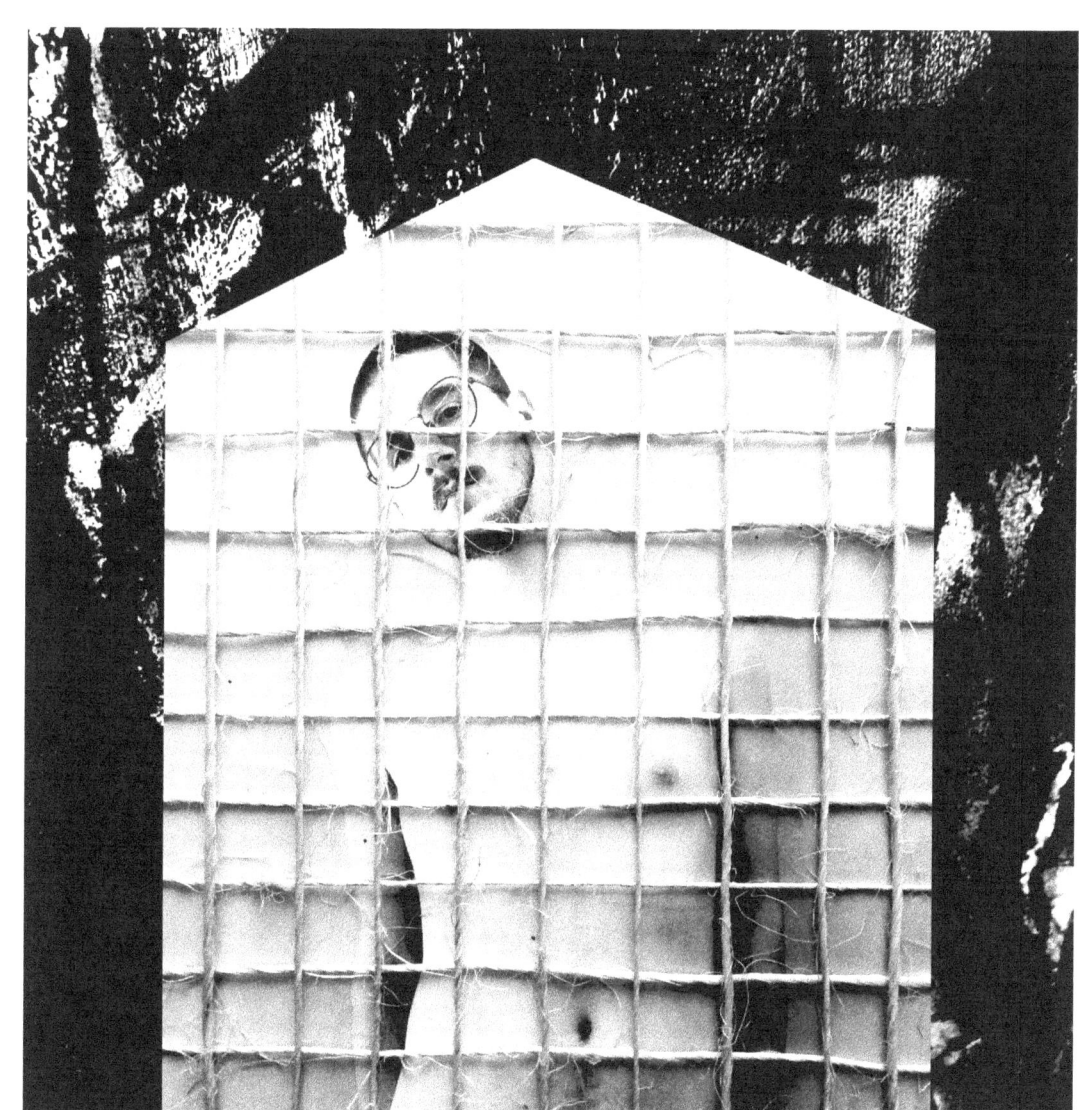

"thirty five"

april 18 2016

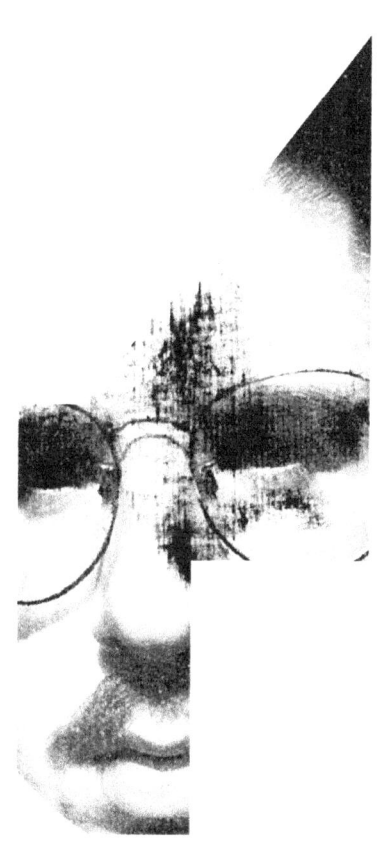

may 30 2016

nighttime bedtime our time

sour grape scent your sweet sassy mouth in my ear whispering flowers

milk curds on the bedsheets and sweat on my brow

dirtier than the mind before

all my words fall from my mouth like drool dripping over you

a god in the flesh a god i will worship a god who has delivered me from evil

"do the outrage dance!"

may 8 2016

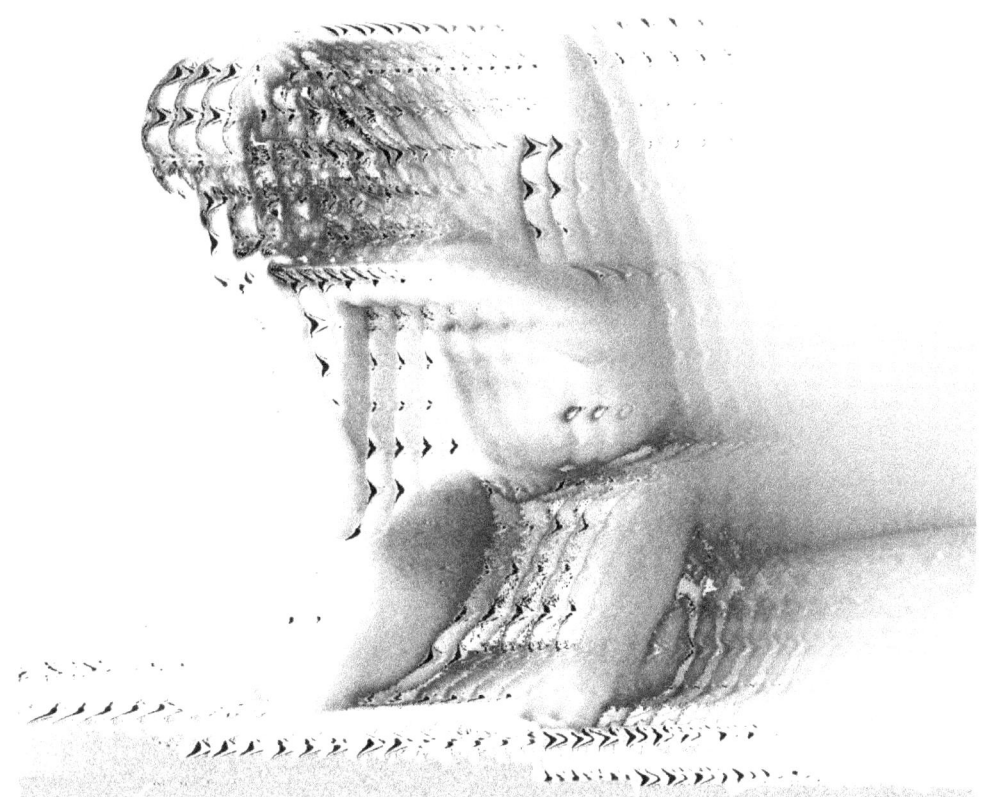

"come kingdom"

june 13 2016

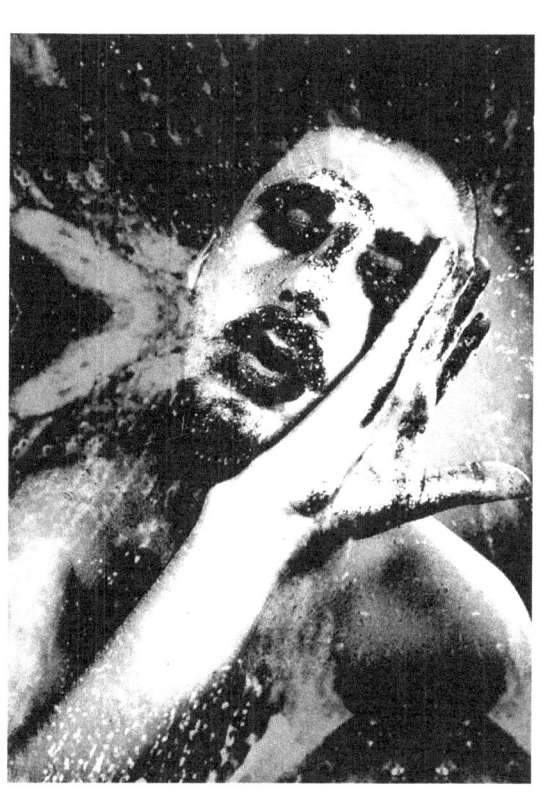

"dead at 58"

july 2 2016

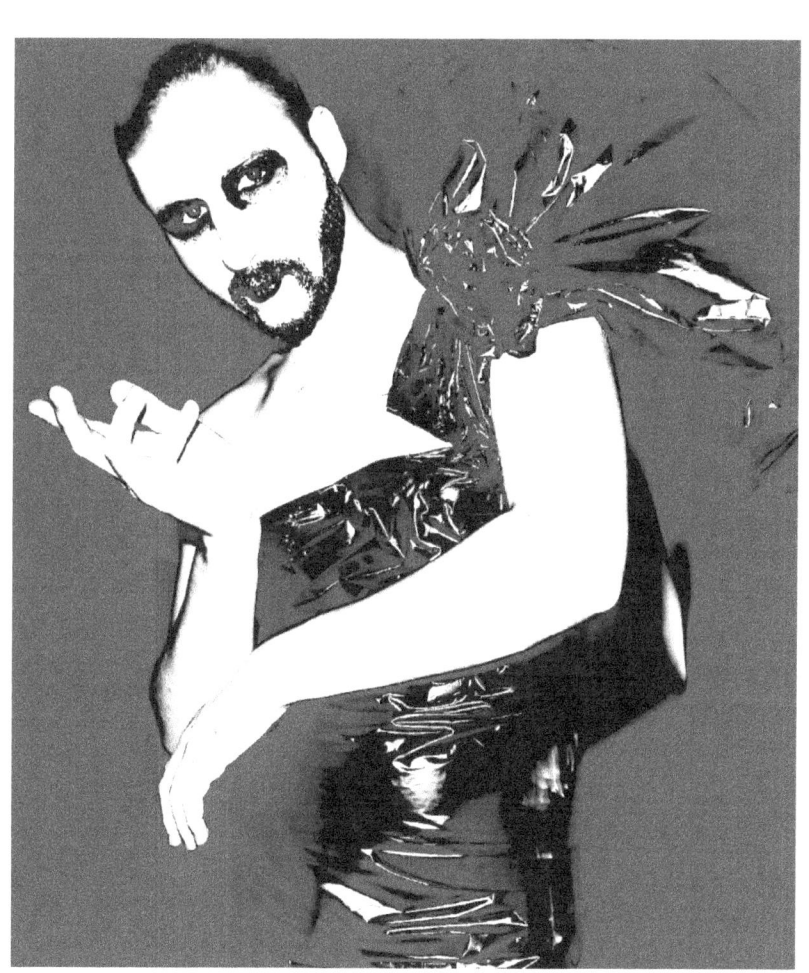

"but where's the poison?"

august 6 2016

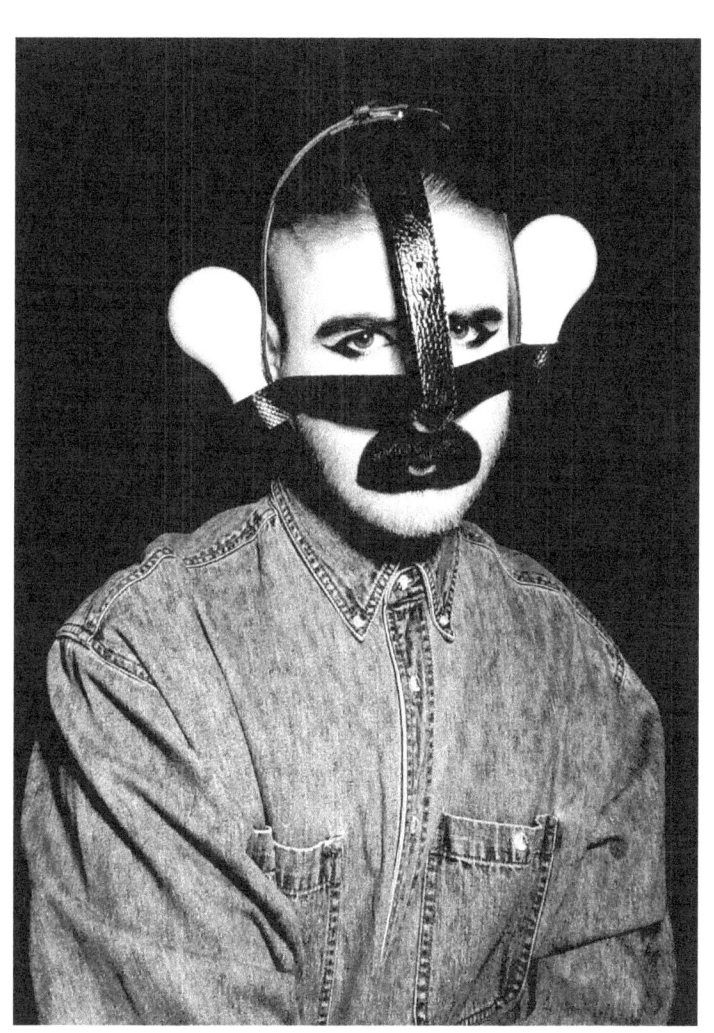

"insurmountable real pain (inevitable distancing)"
august 15 2016

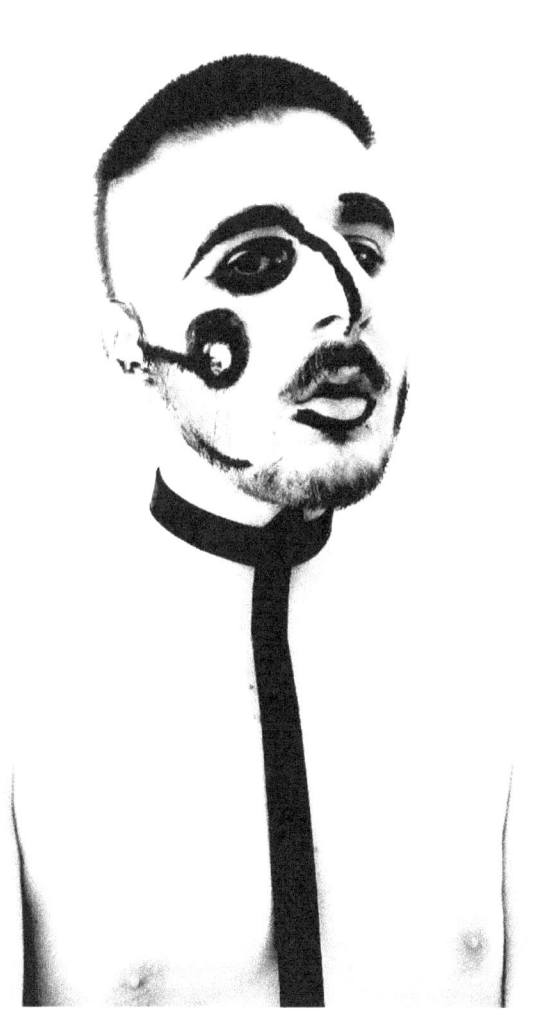

december 22 2016

mindless fairy

she's kissing him in front of me again

lying in his bed talking about bones

feeding the hot tub Doritos sharks

i'm crying on the carpet again

"heaven preserve you"

september 3 2016

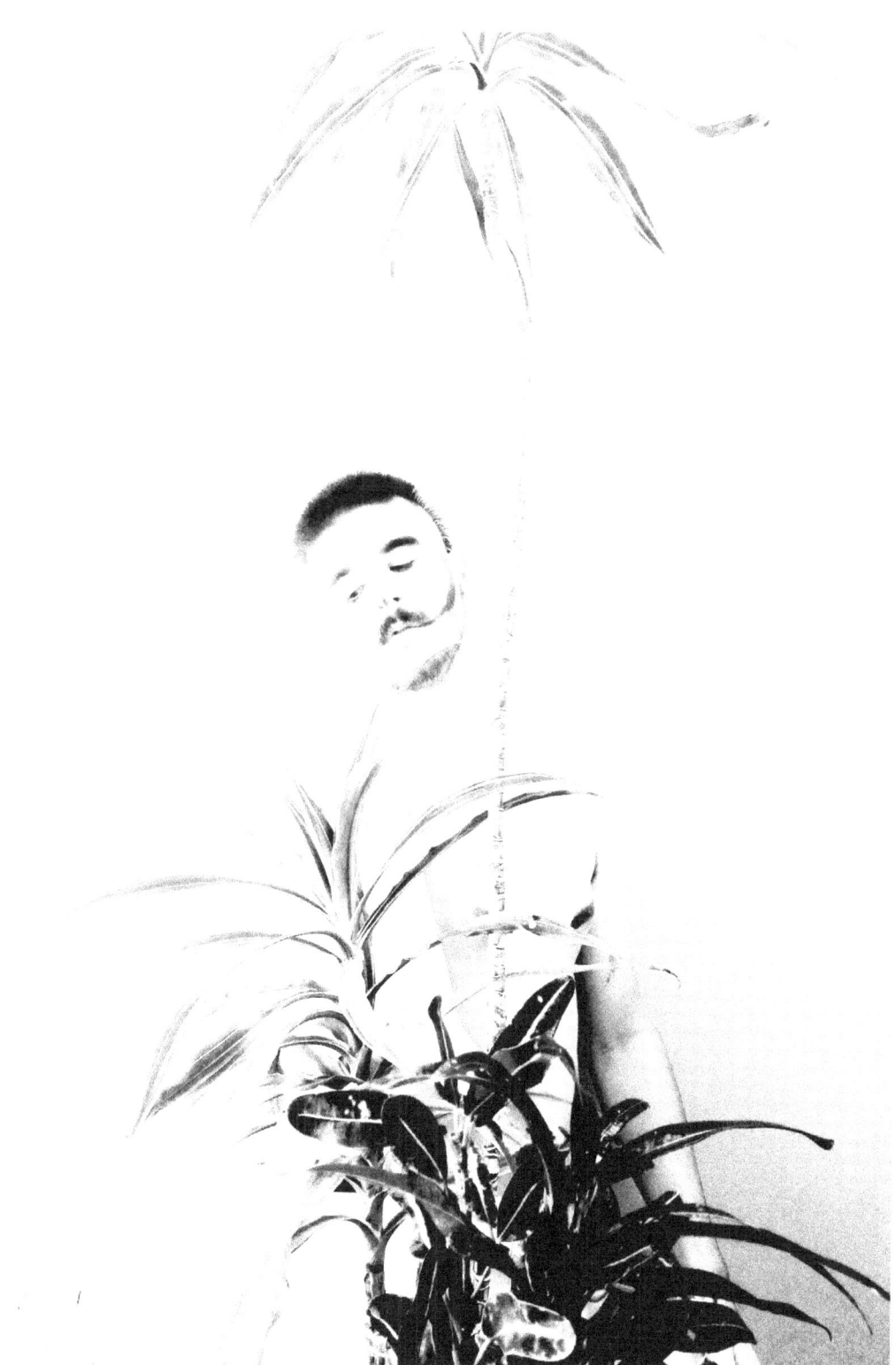

"oh such dangerous fashions we seek"
september 9 2016

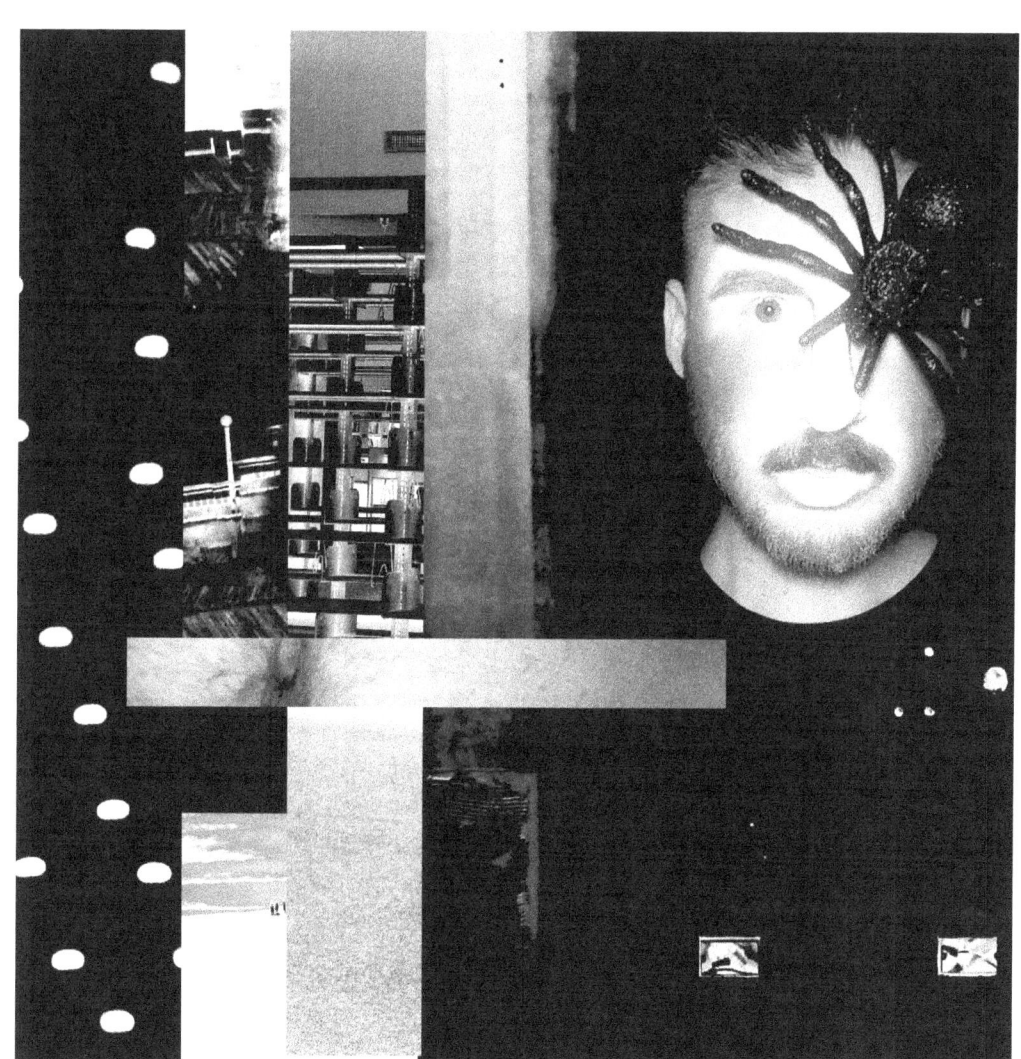

may 29 2016

cast a shadow throw a net put a hex on me

move my body to the floor and progress to what you need

bones cracking bed creaking brain screaming Quiet cramming weight in the ass like hands to the gun trigger trigger barrel fun

let the ocean guide our bodies together interwoven together combined together

we throw the books off the shelves and move into our shelter for the evening anticipating the fall of night

wrestling with the stars naked well fed restless and energetic

veins like lightning bolts

dying and being reborn on repeat i'm under your spell i'm under your body pulsing pulsating pull me apart with your warm hands

my bigger love is sexy to me

"woman ray"

september 15 2016

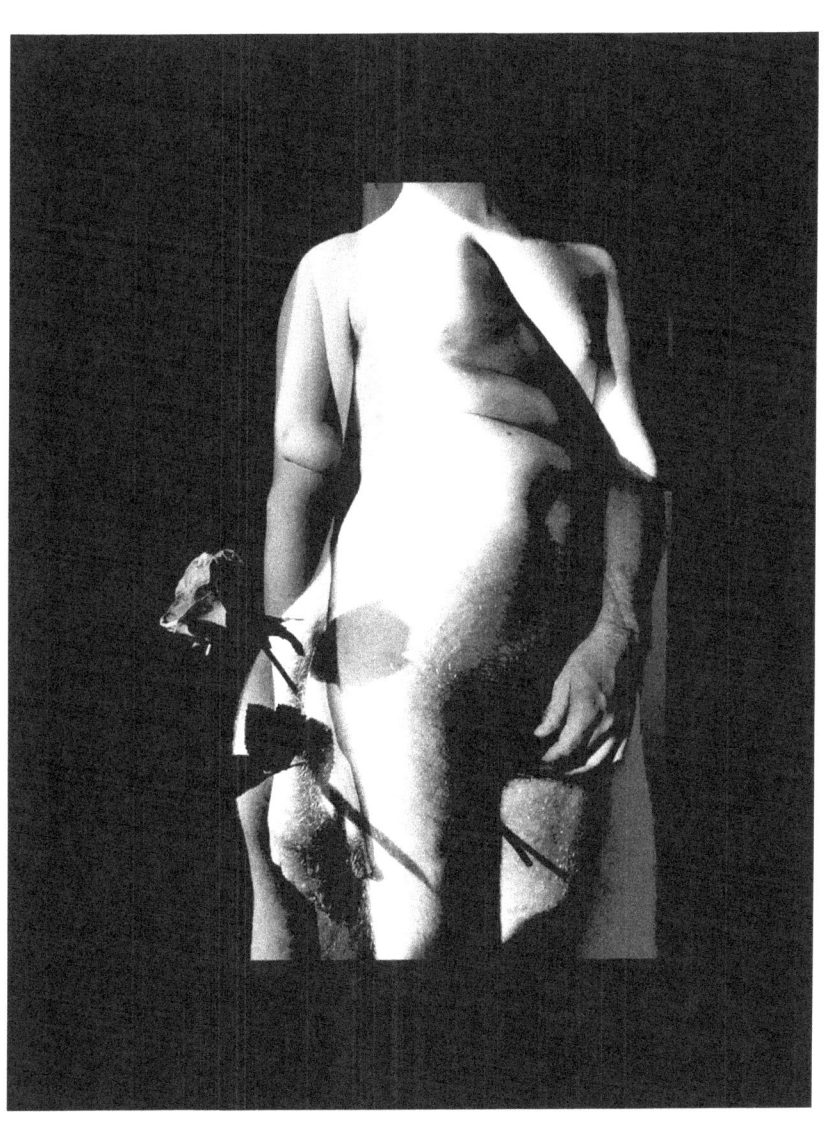

"Quiet jaw (gravity's pull)"
september 29 2016

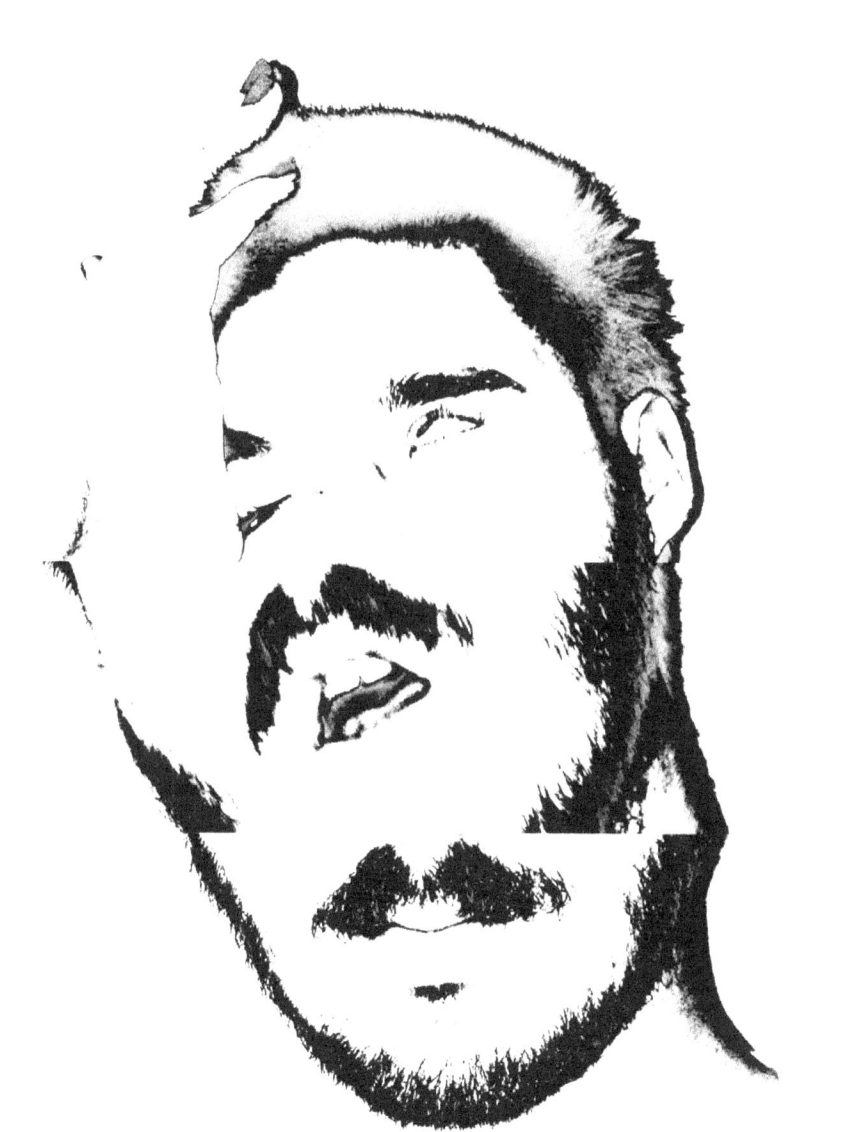

august 14 2016

European blasphemy

fire on the front step

lungs crippled with confusion

i dreamt that i was fluid like air

stealing everything leaving nothing behind

i've been frozen before

in the headlights of the coming vagabond

never had they seen such a rotten show of gore

take a swig and kill the car

"gears of politics (trust)"

october 8 2016

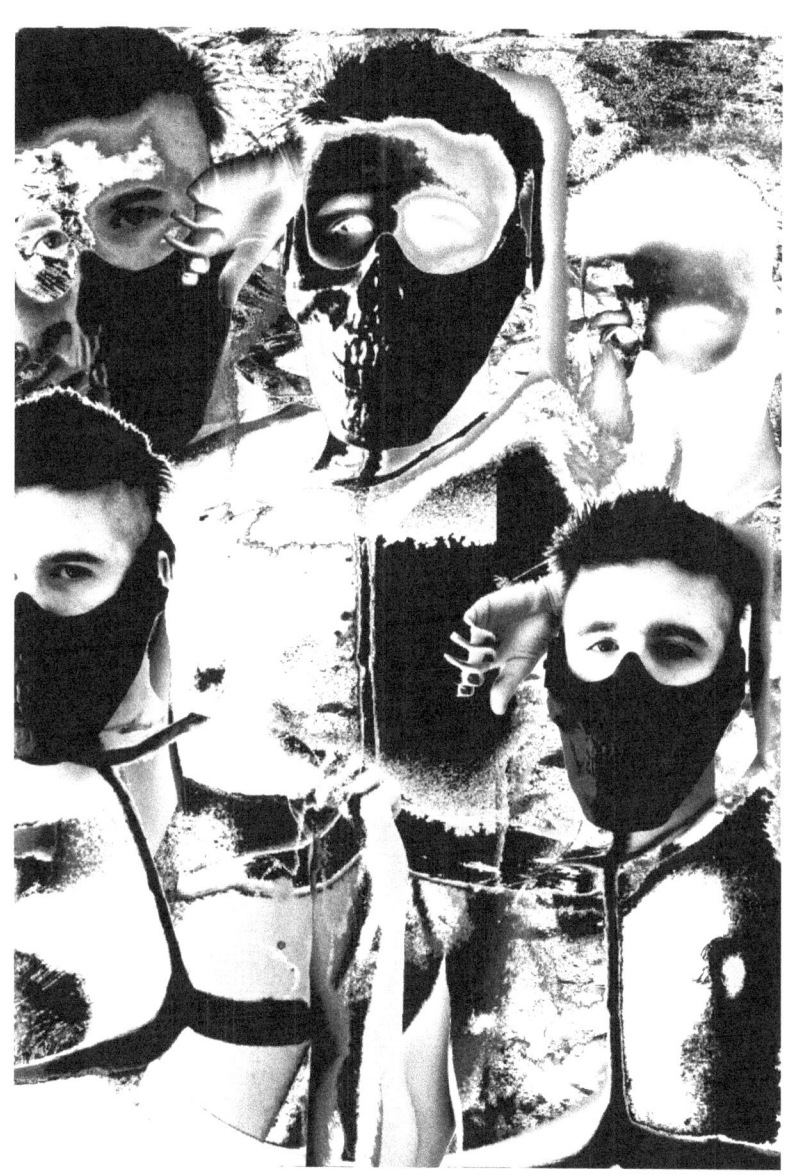

"what a waste (son of Sam)"

october 8 2016

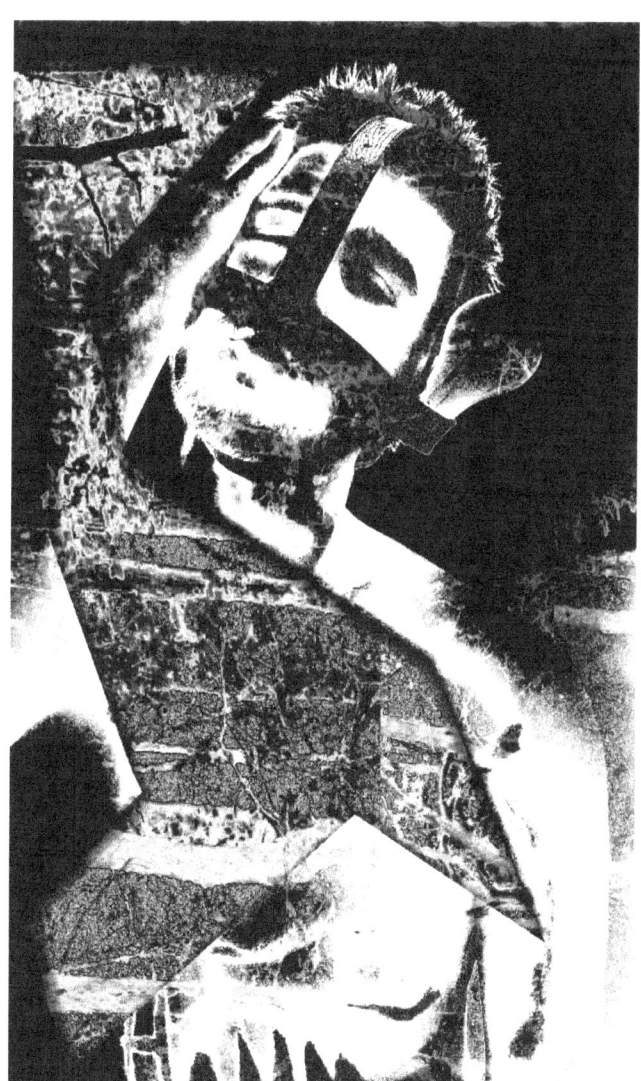

"milk wound"

october 12 2016

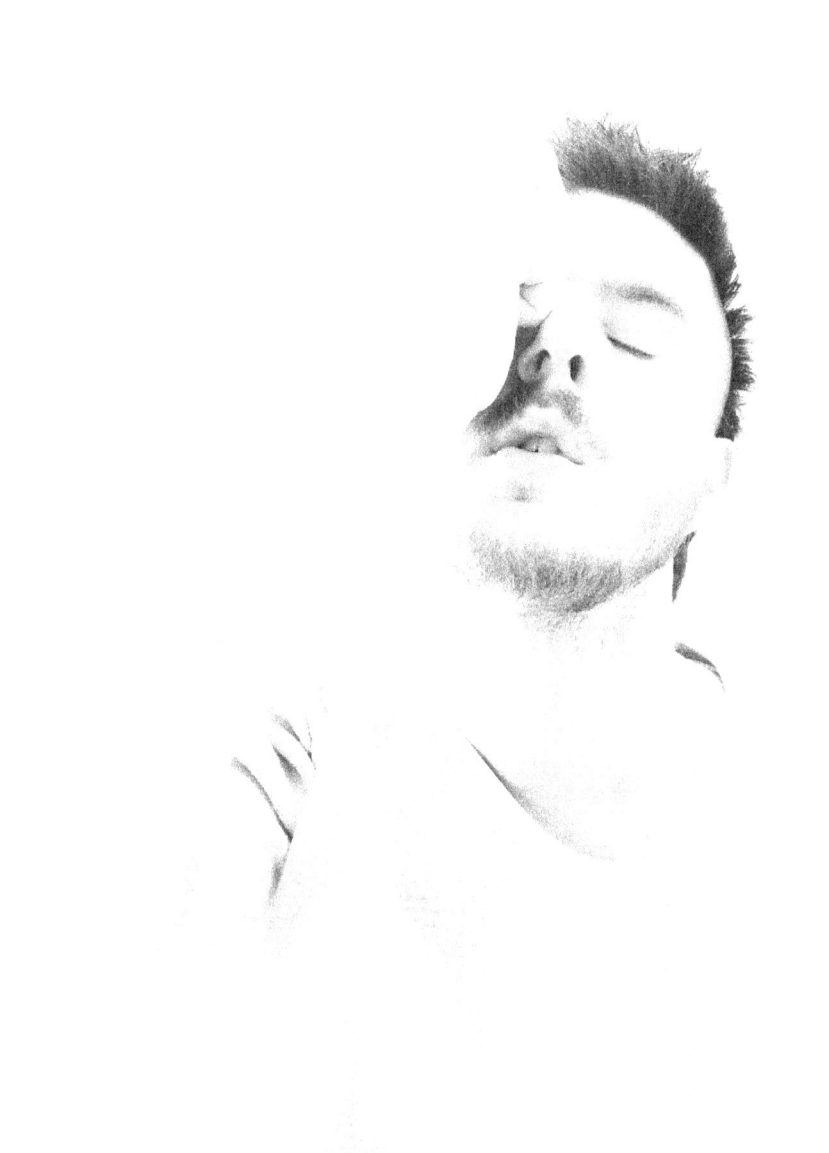

august 29 2016

my gills expand with oxygen

and my heart grows heavy

i dip my sweaty fingers in your broth

"sour grim"

october 13 2016

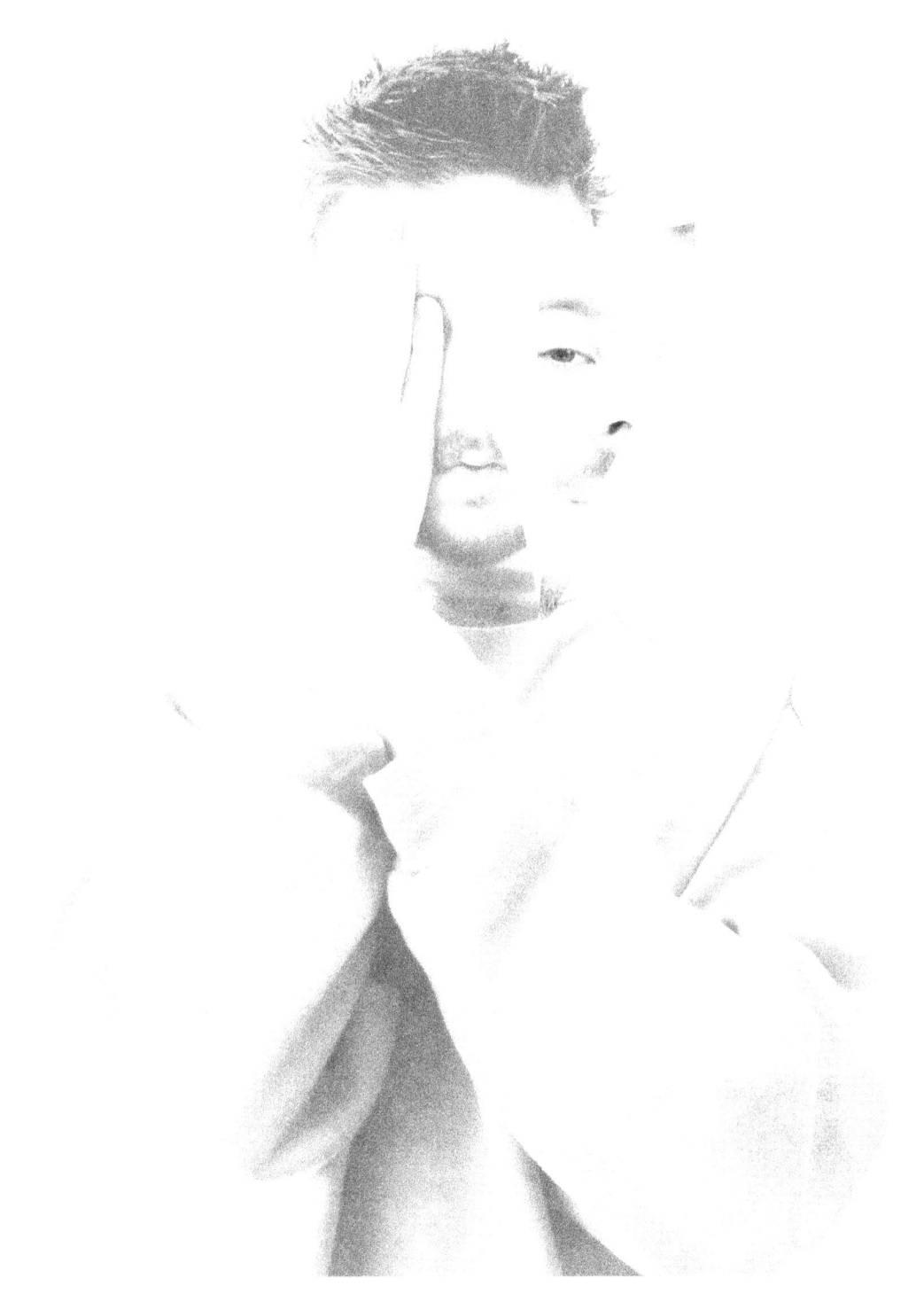

"terrible past"
october 13 2016

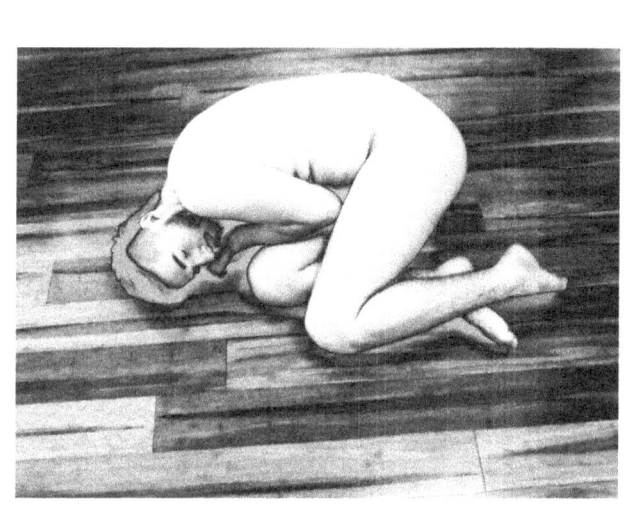

may 22 2016

intoxicated by the odor of man crotch

5 am looking to feed my wolf

enhanced entranced amidst the allure of penetrative gazes

in black dark messes violation and eternal damnation

nooses under the covers

gagging and choking on a brand spanking new hour

suffocating on the sunlight

white liquid thunder down my throat

"when are we quiet?"

october 13 2016

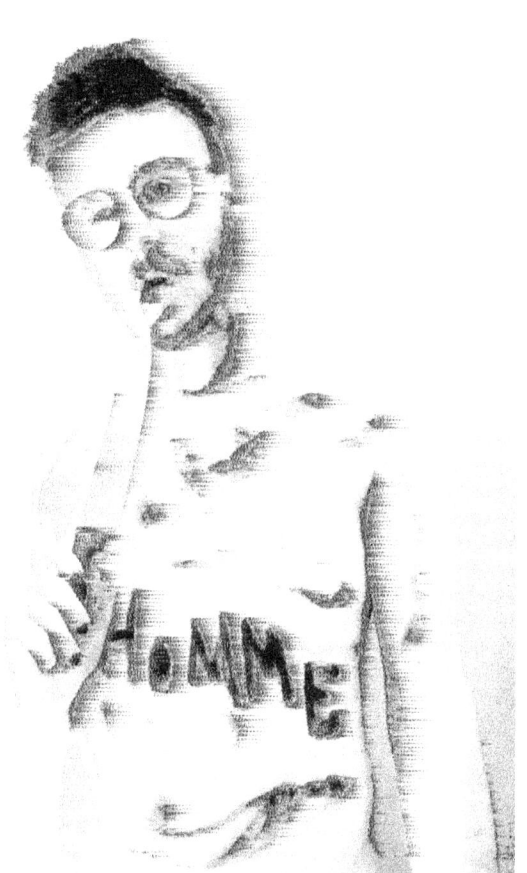

"the rifle must absolutely go off"
october 15 2016

pain by the hand of you
heather gray smoking
truth crying hallway weeping
losing grip as i walk
 killed our relationship as two bodies
 pointing back

december 25 2016

fingers bloody blistering rubbed raw

digging around in glass

rimming the barrel crust

it's not enough to be here and not inside of you

"lick the scars and drink the tar"

october 16 2016

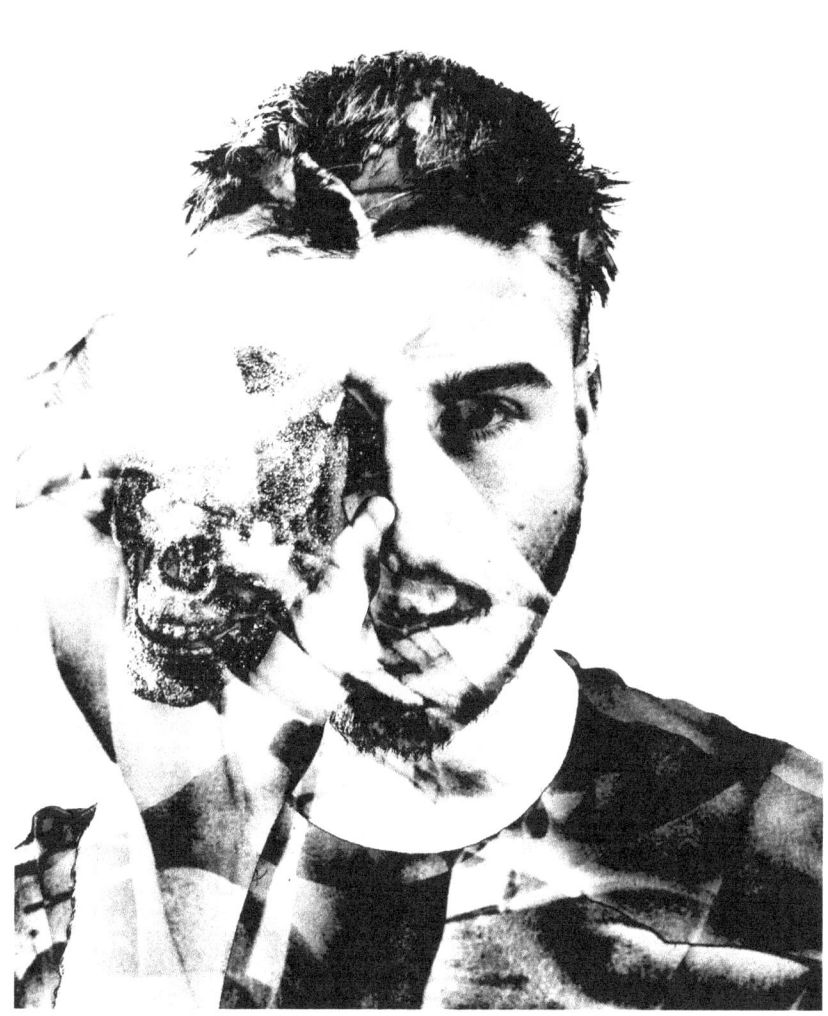

"altars iiii"

october 17 2016

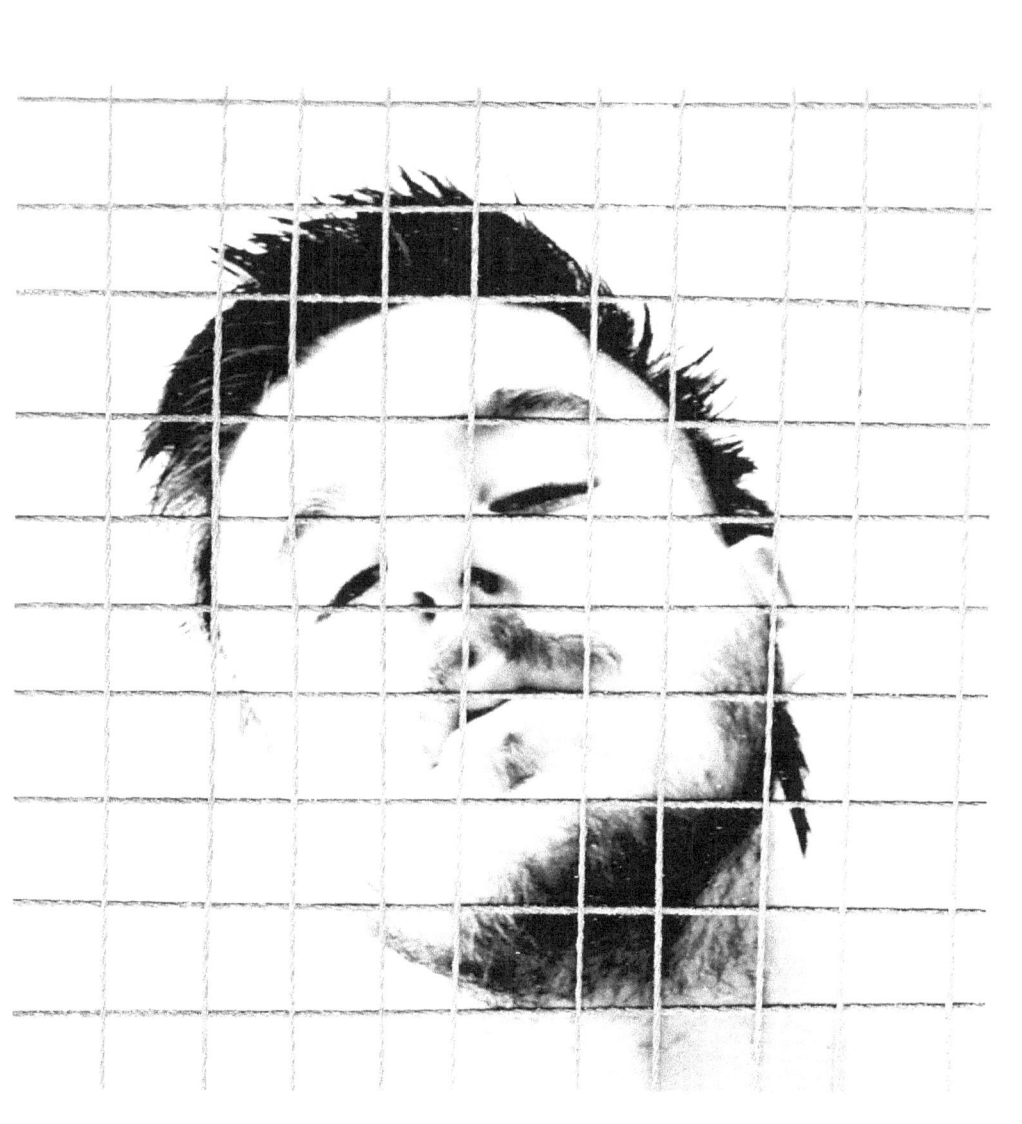

"this tongue will seduce (dry country)"
october 19 2016

april 24 2016

full body fire flaming higher hotter burning harder
hot hot angry sun in the sky and sin on my mind
hot hot sun that drives me into a lusty flame frenzy now
screaming about Christ ripping hairs from my scalp i'm trapped in the wrong body like before
you're gone again but this time for sure and for sure the shore will drown me tonight
on the bible i'm swearing in i'm swearing it i can't shake this feeling and i'm going to smash the
stain glass window tonight if i have to i have to i know i do
the firefight inside of me is a charcoal pit filled to the brim with old wood and the sparks are
garnering heat and growing in size and magnitude and intensity
atmosphere thickening with smog and i'm choking on the ashes of the person i used to be
surfacing are the old times the good times the times we didn't remember time or the world around us
we just lived and remained close to each other like heaters in winter like air conditioners in summer
i'm wading in black water in my briefs with you and only you by my side forever or so i thought we
would remain conjoined and in love with the vertigo feeling
riding rollercoasters and driving backroads through the forest
fast food under brown moonlight apocalypse
poor and filthy and lost but content with the place we both existed at together inside each other
kissing concrete at gas stations
in love with the suicidal summer serendipity and your tongue down my throat
i'm crying dragging the blade against my flesh trying to exorcise the thoughts of a love now not
reciprocated but parched and dehydrated and hungry and starving in the streets
my body still needs you like it needed you three years ago just a naive youth
burning with the thought of the thunder clapping against my thighs
with waves below our breaking bodies breathing hot and heavy
your power scraping the walls of my fragile peace wiping away my tears of loneliness at midnight on
a Tuesday or whatever day i snuck you in the backdoor

but now the sun has set and my body is naked and alone

"root kid"

october 23 2016

"my bed is in a hole in the backyard and it's raining"

october 25 2016

"tiger bite"
october 27 '06

december 8 2016

the noxious stench of what i fear most

masculine men mocking me with their headlights

me and my lizard haircut tossing and turning

with galaxies in my milk

ask me how to breathe heavy

"sky scratches and dangerous politics"

october 29 2016

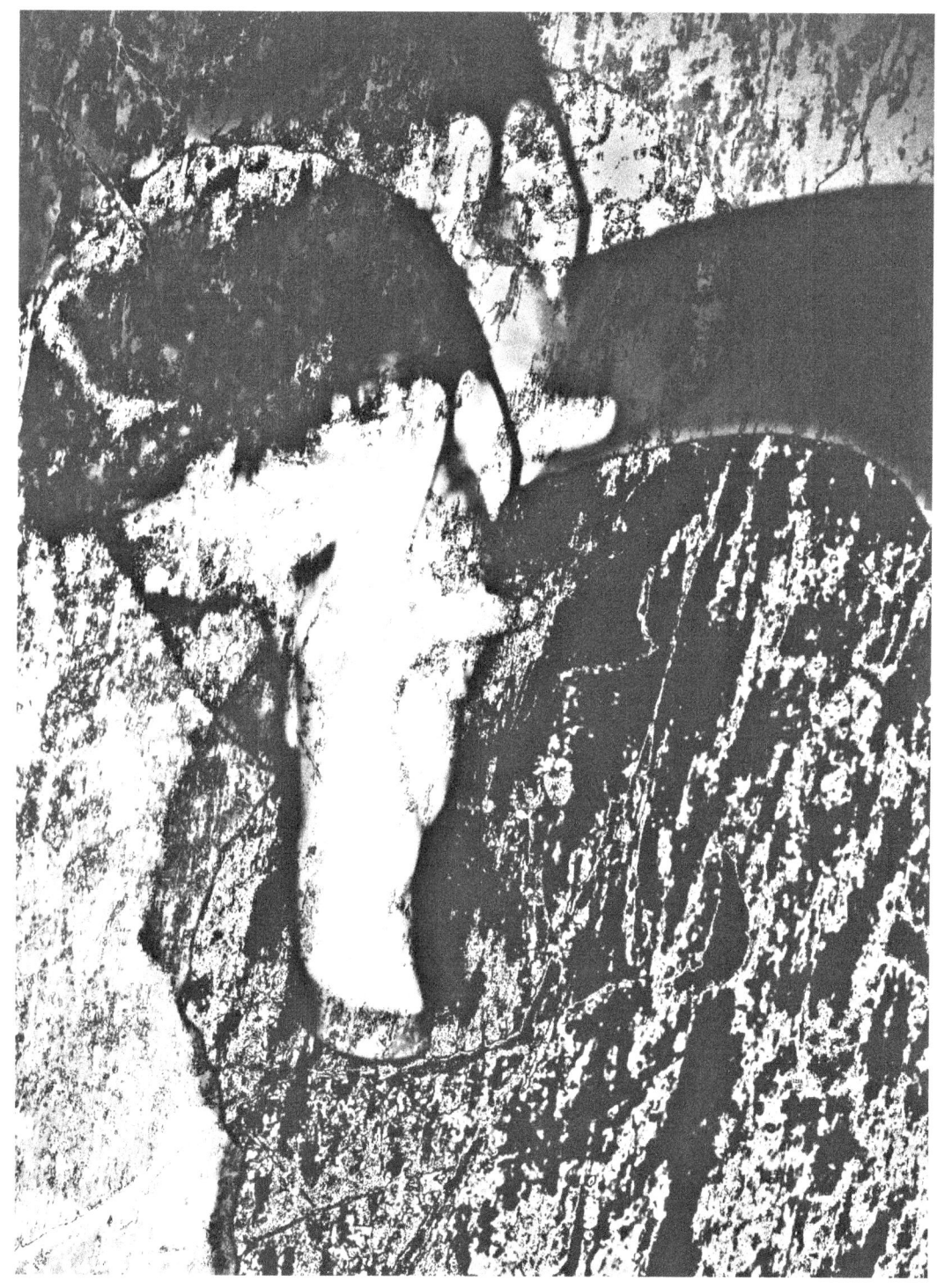

"get up boys"
october 29 2016

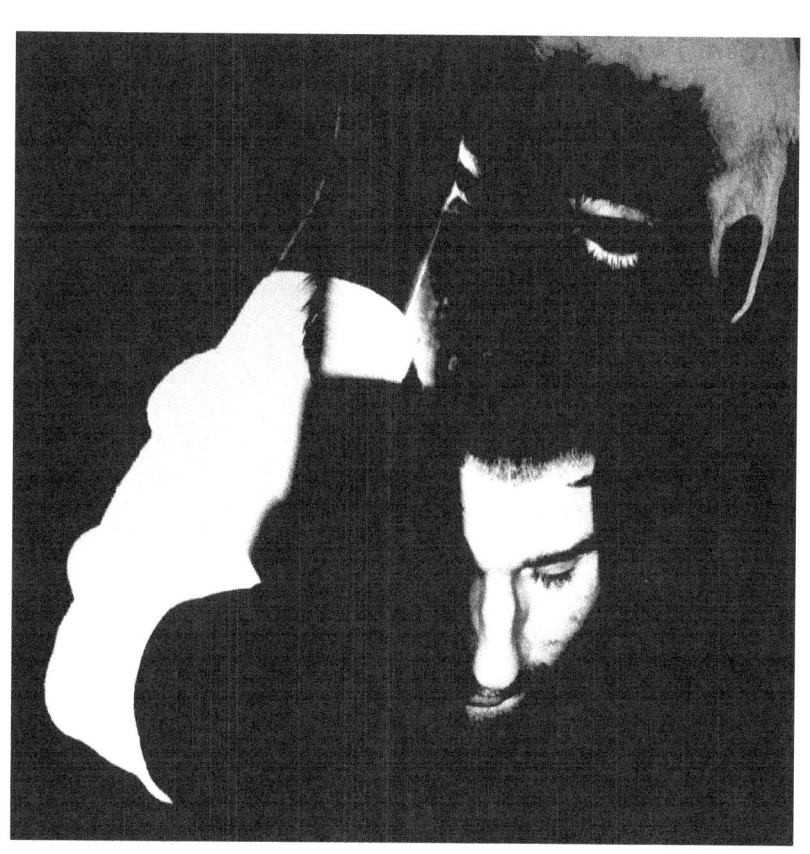

july 7 2016

couldn't catch the crime

marvelous memories remain as scars inside my skull

i sigh i sigh i sigh because it is all i can do with my malice

because trauma knows no saints

"destroy your past"
october 29 2016

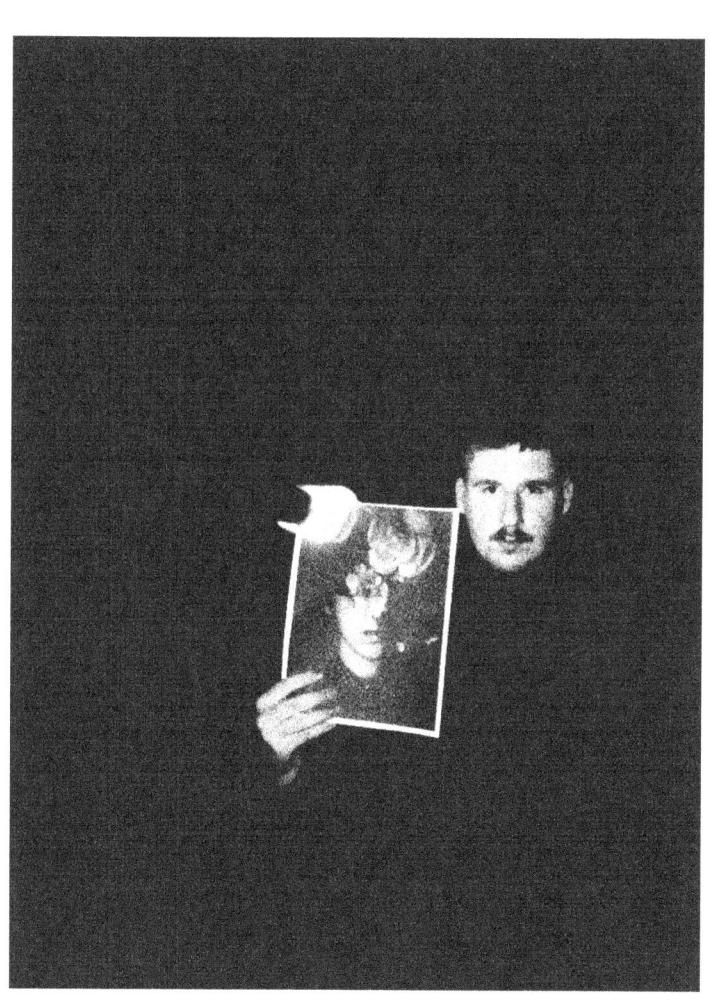

"all the boys i meet evaporate"

november 16 2016

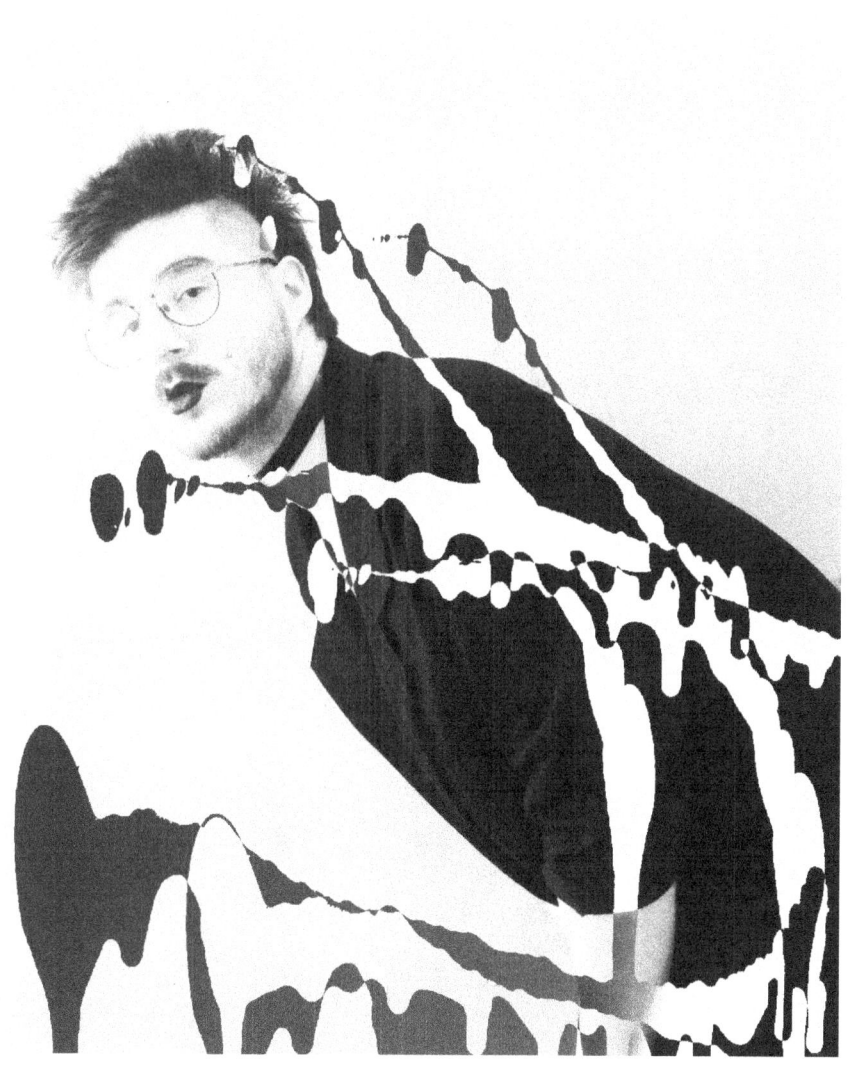

"the only piece i need"

november 24 2016

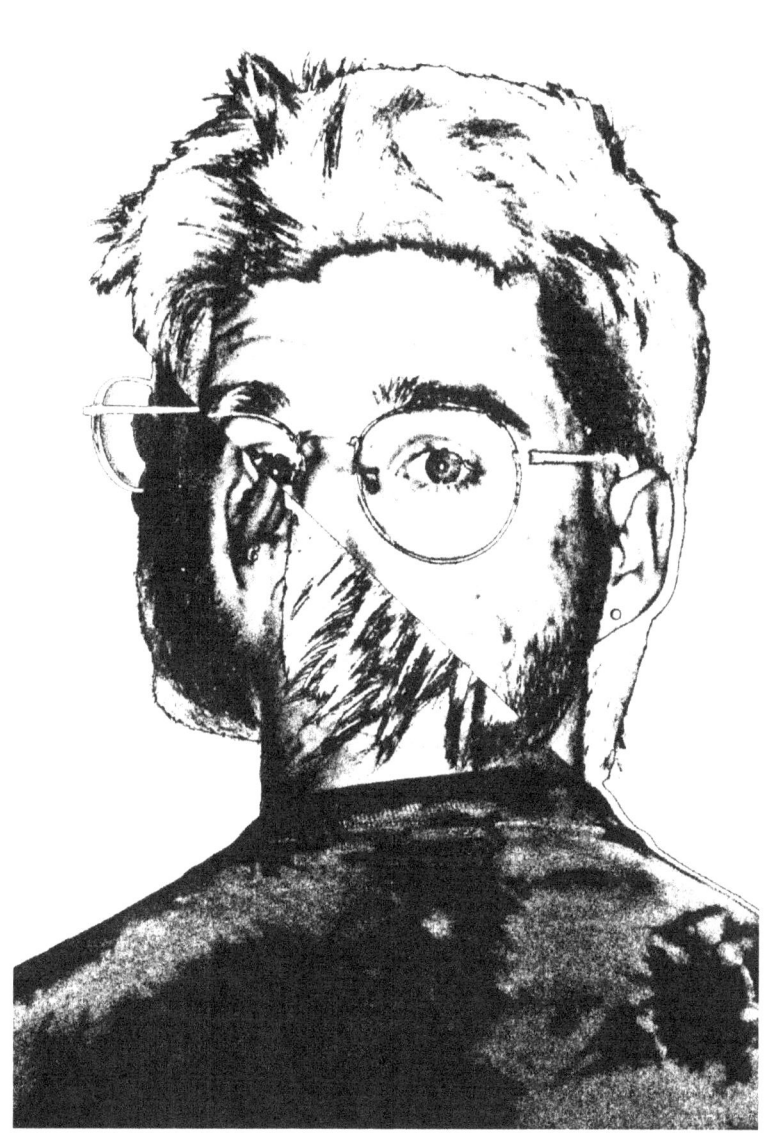

"lost sensibility"

december 5 2016

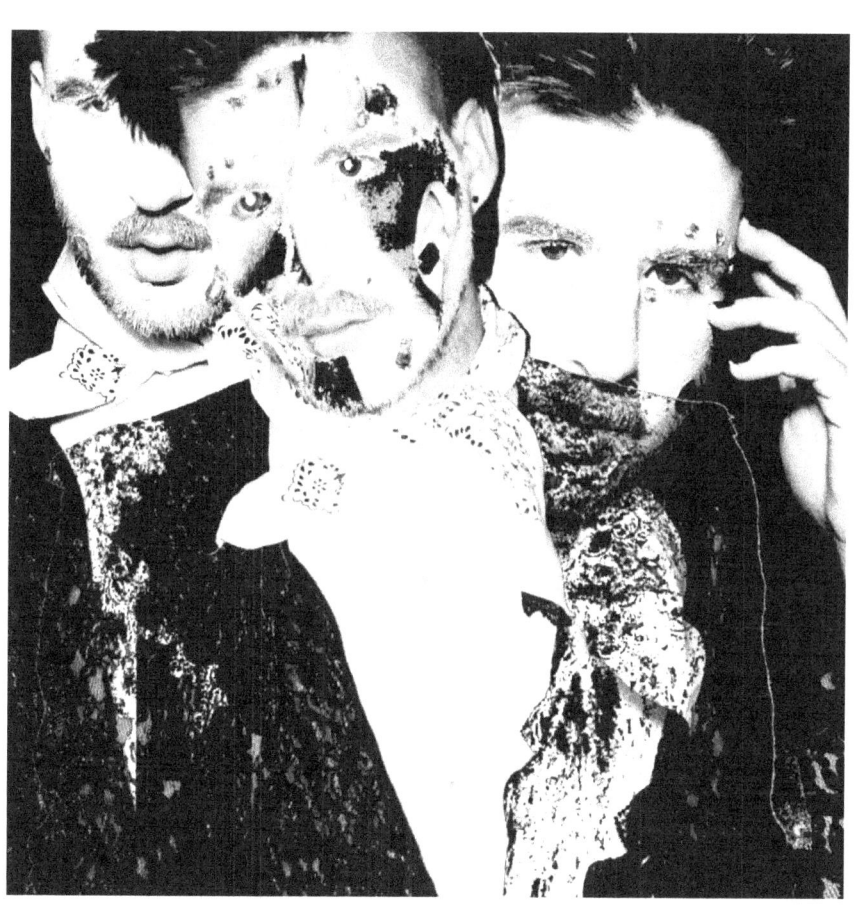

december 10 2016

hard humiliation

soft bellied sex

intake increase

confusing feverlust

secondhand high

i get my thrill and depart

"feverlust"

december 10 2016

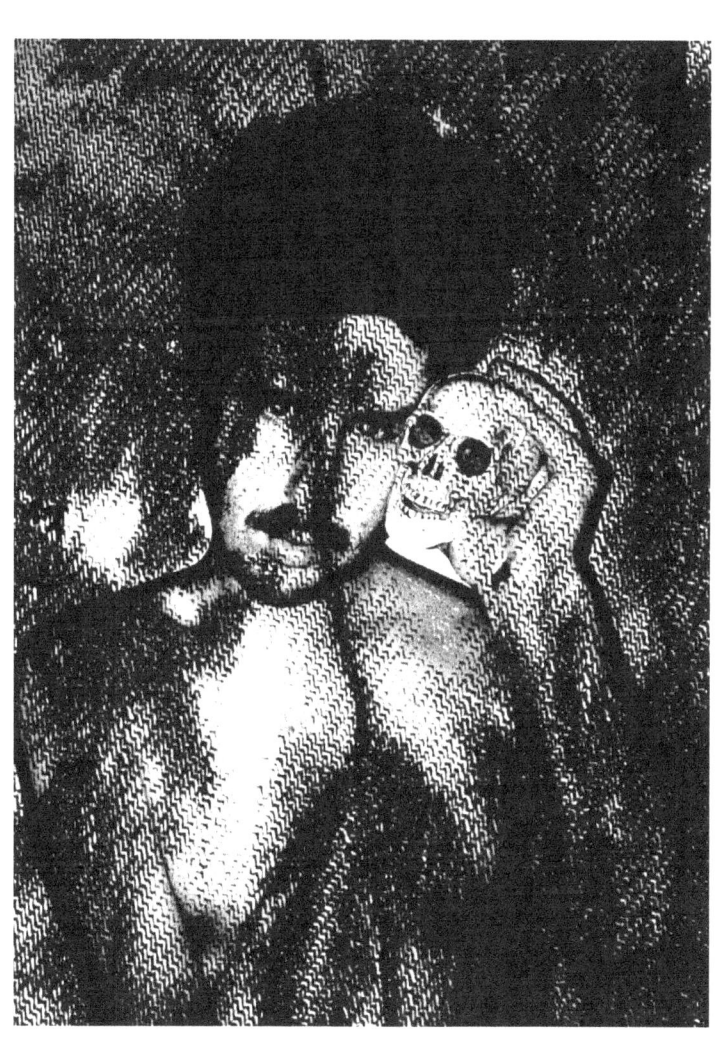

"rancid at the root"
december 25 2016

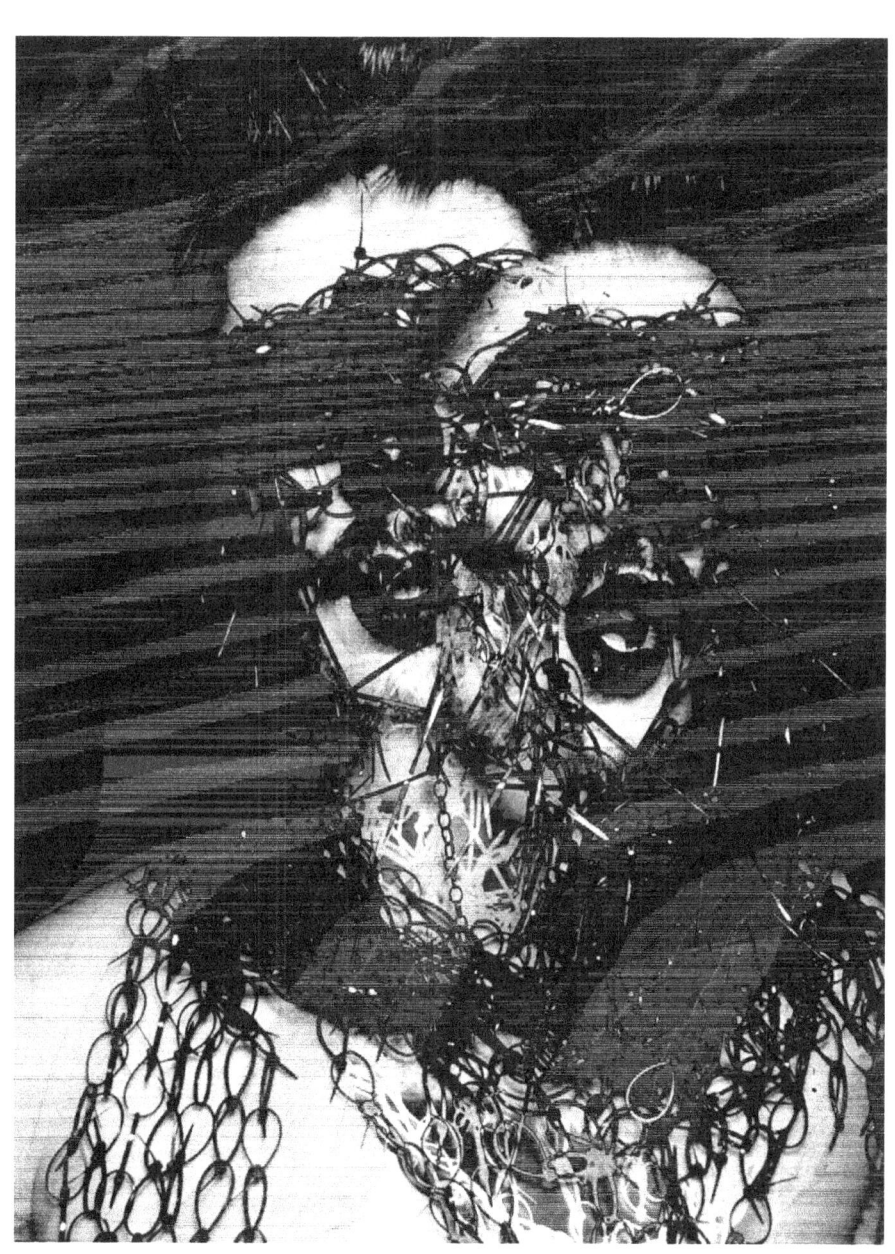

july 11 2016

i massage his gums with my tongue

he says i make him feel human

i tell him he is understood

he walks the tightrope every night

"jackals"

december 27 2016

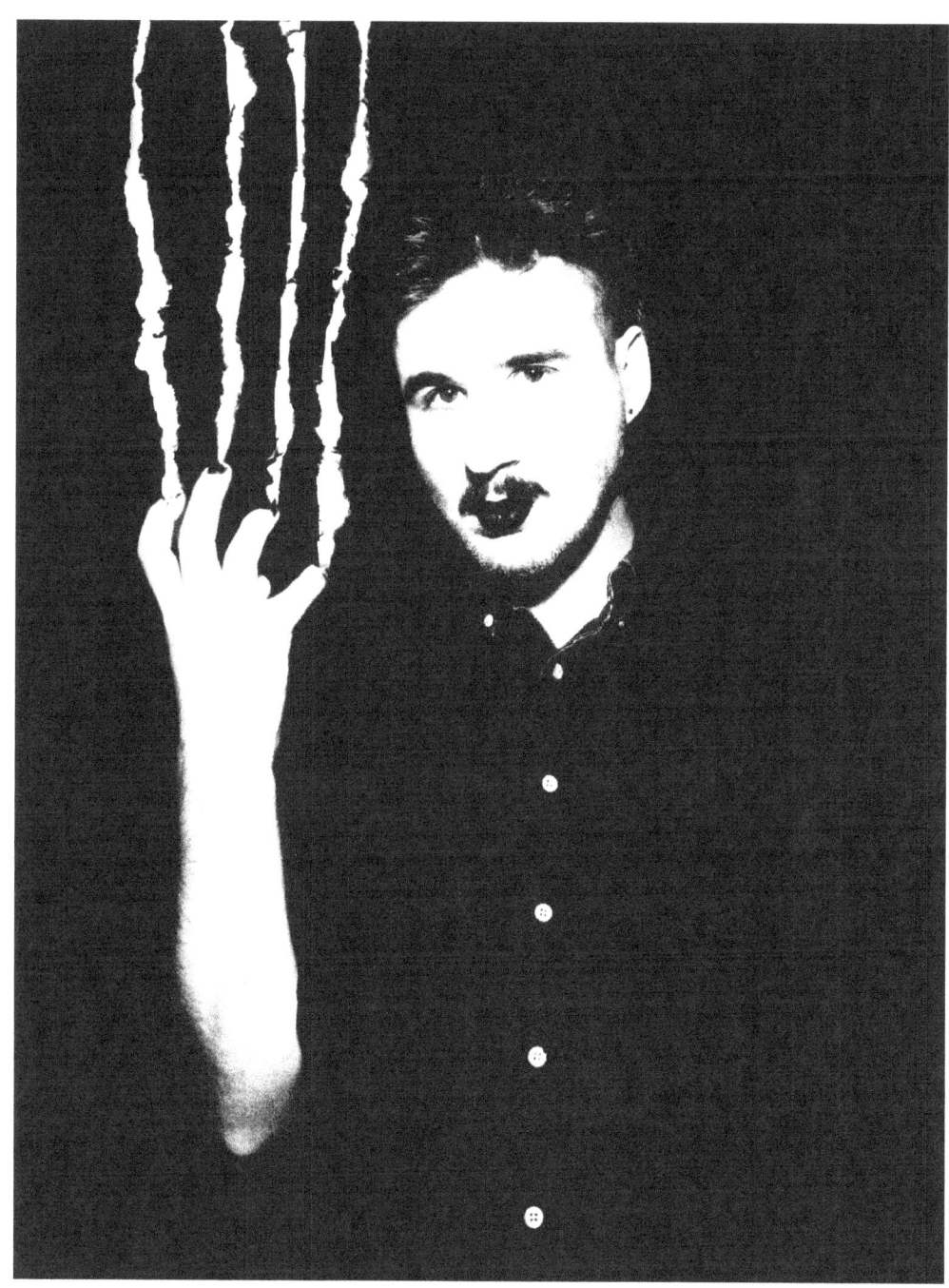

december 26 2016

year away

return soft spoken flame

with fluttering nervous organs

gold from ash

he wants to restart

so my heavy heart reboots

lost but found again

torsos touching

sharing the skyline

the minute we shared never left my tongue

your breath like a candle extinguishing my fears

"laze"

december 28 2016

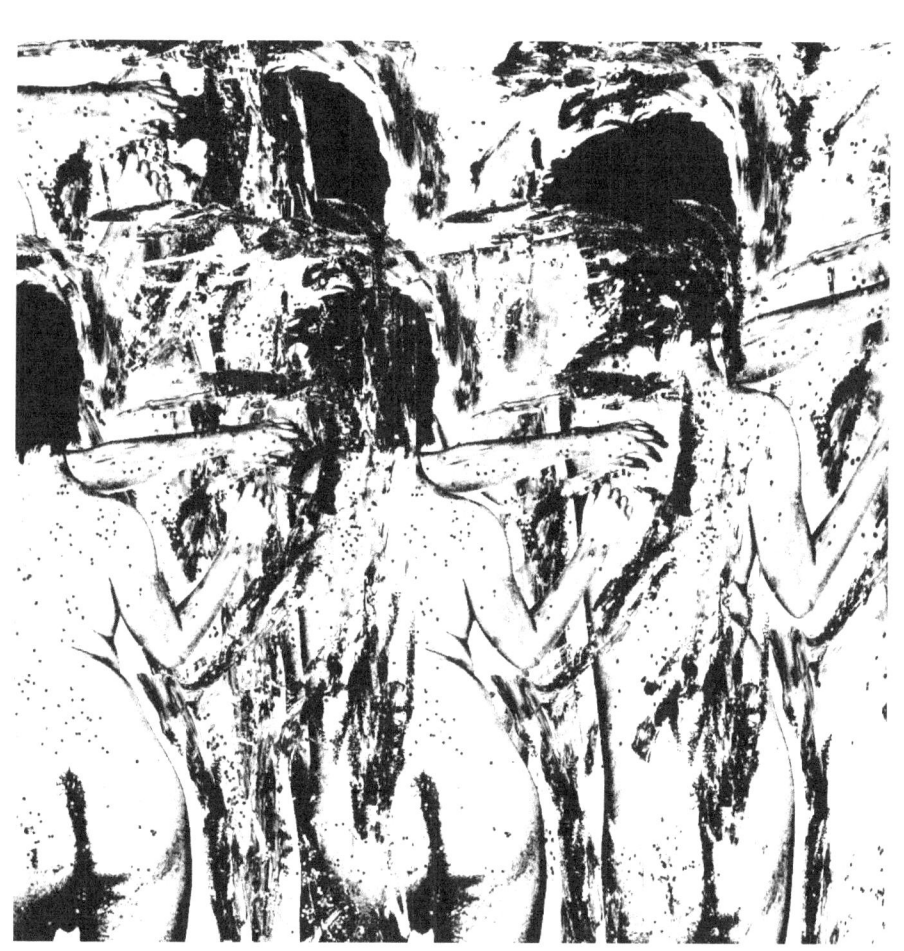

january 20 2017

all the ice melted

i'm sweating in gallons

you make me dizzy

little king

our undeniable magnetics keep us coiled in barbed wire

"NYC with you"
january 6 2017

"silent Sagittarius"

january 9 2017

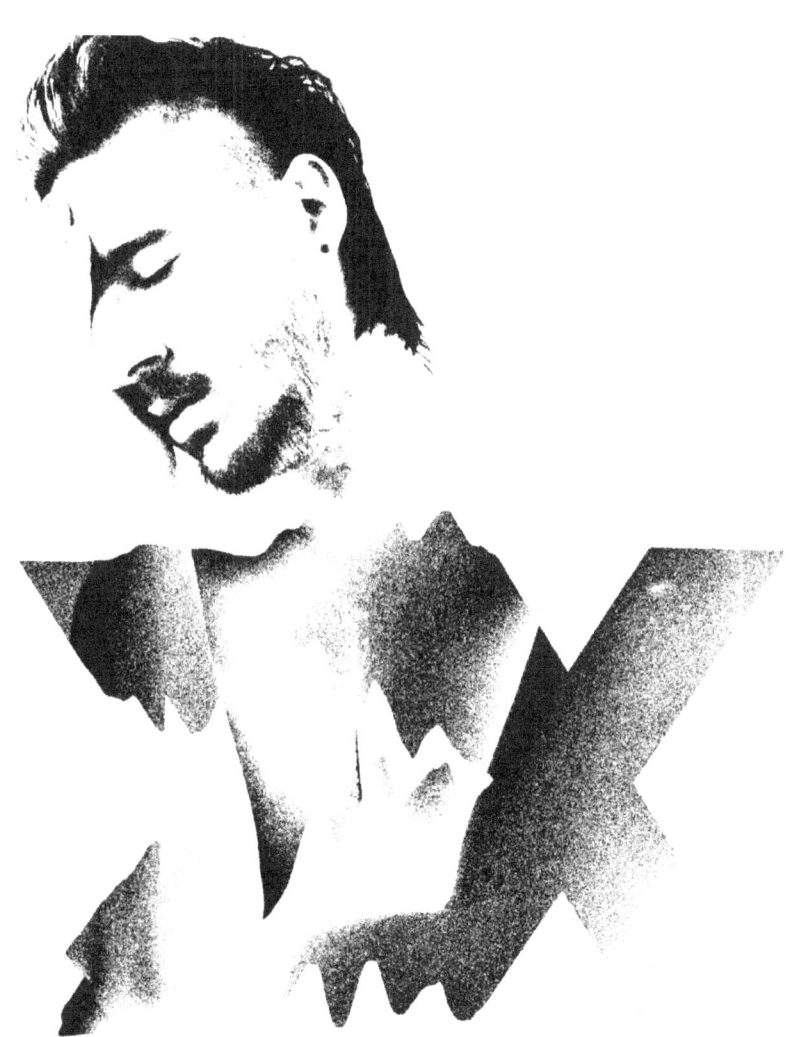

"let lips do what hands do"

january 13 2017

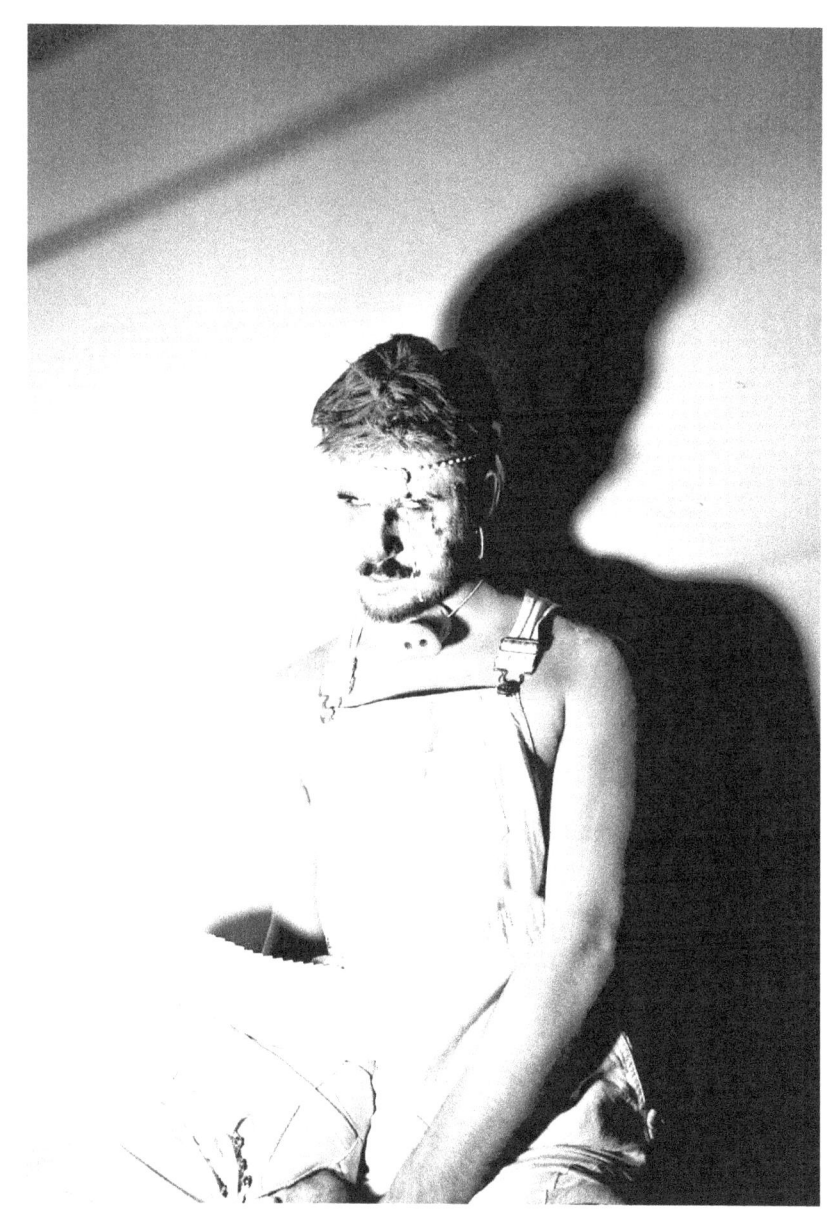

pick your culture
LB 1997

loganbenedict.tumblr.com